LEARN
PHOTOGRAPHY
IN A WEEKEND

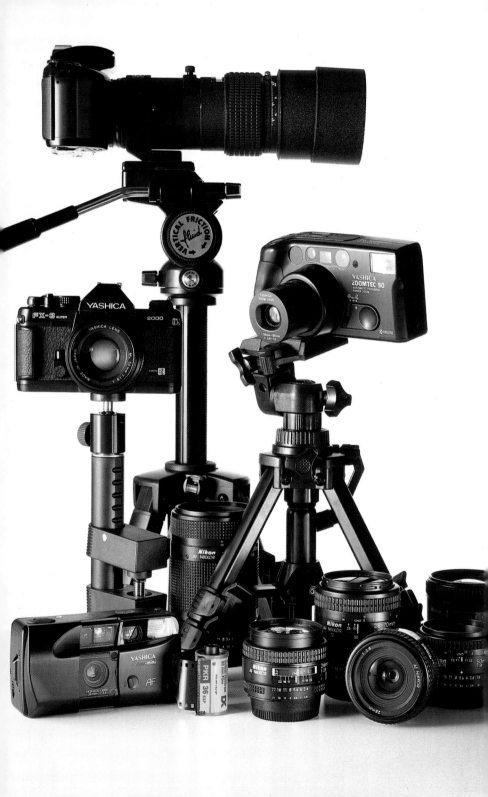

LEARN PHOTOGRAPHY IN A WEEKEND

MICHAEL LANGFORD

Photography by Philip Gatward

ALFRED A KNOPF

New York

1992

A DORLING KINDERSLEY BOOK

Art Editor Kevin Williams
Project Editor Jonathan Hilton
Series Art Editor Amanda Lunn
Series Editor Jo Weeks
Managing Editor Sean Moore
Managing Art Editor Tina Vaughan
Production Control Deborah Wehner, Helen Creeke

This edition is a Borzoi Book published in 1992 by Alfred. A. Knopf, Inc.,
by arrangement with Dorling Kindersley

Library of Congress Cataloging-in-Publication Data
Langford, Michael John, 1933-
 Learn Photography in a weekend /
Michael Langford. -- 1st American ed.
 p. cm.
 ISBN 0-679-41674-9
 1. Photography I. Title.
TR146.L294 1992
771--dc20 92-53044
 CIP

Computer page make-up by
The Cooling Brown
Partnership
Reproduced by Colourscan,
Singapore
Printed and bound by
Arnoldo Mondadori,
Verona, Italy
First American Edition

CONTENTS

INTRODUCTION

THE AIM OF THIS weekend course is to give you a start in making more creative use of your camera. It will prove that there are more picture-making possibilities than simply pointing the camera and asking somebody to smile. Each stage of the course suggests ideas for exploring visual techniques and how to apply them. Nobody should expect to become an expert in a single weekend. For one thing, it is vital to assess your results at each stage, and so you must allow time for a good processing laboratory to produce your prints or slides. Consequently, this course is probably best tackled in equivalent time slots over several weekends. The best way to use each practical session is to plan, observe, shoot, and assess results. Planning means setting yourself a project, and applying the

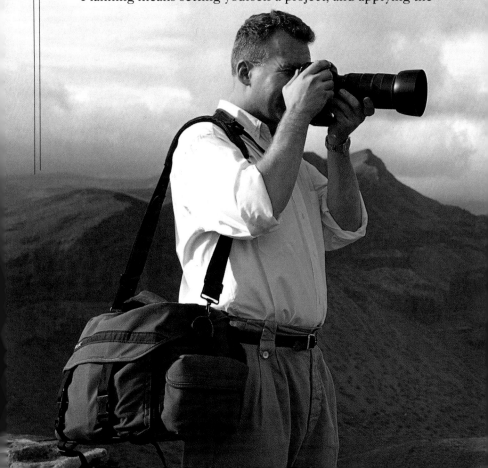

particular theme to the subjects and situations available to you. Observing means recognizing the visual possibilities of what is in front of the camera. Shooting is partly technical, partly seizing the right moment to release the shutter. Assessment of results is the only way to judge your progress and to decide whether or how to reshoot. I believe the main benefit of photography is the way it enhances how you see the world. You become more conscious of lighting, depth and distance, the influence of colors, the way in which one element directs your attention to another. This visual awareness is more important than using the latest camera, and it grows from taking many different photographs under many different conditions. Whether photography is an art will always be hotly debated. In creative hands the camera can produce images that are powerful or poignant, evocative or dramatic. Above all, photography is fun – it takes you out into the world and provides a store of visual memories that are of increasing interest as the years roll on.

MICHAEL LANGFORD

PREPARING FOR THE WEEKEND

For best results, familiarize yourself thoroughly with all your equipment

THINK CAREFULLY about the camera you intend to use. If you are buying a camera, choose one with a viewfinder that is comfortable to see through (especially if you wear glasses). You should not forget to check the positions of any buttons, rings, and other controls – these need to come easily to hand. A basic decision you will have to make is whether to use a fully automatic model or one with manual settings. Automatics are convenient, but don't teach you much about

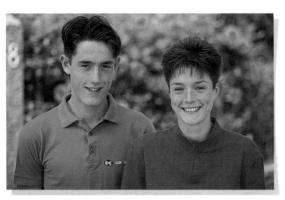

AUTOFOCUS

Cameras with autofocus (**AF**) can be fooled by even a simple subject like this. AF systems measure subject distances from anything in the middle of the frame – here the foliage in the background, not the figures. To overcome this, center the subject in the frame, and then lock the focus setting into the camera, before recomposing the image and taking the picture (see p.13).

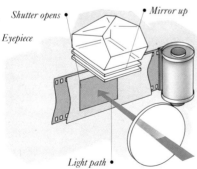

Shutter opens • • Mirror up

Eyepiece

Light path •

LIGHT PATH

In a single lens reflex camera (see pp.10-11), a mirror behind the lens flips up at the instant of **exposure**, the shutter opens, and light from the subject can reach the film.

CAMERA DESIGN

An **SLR** is very versatile, but it is larger, heavier, and often more expensive than a compact. If you don't use the facilities, is spending the extra money worthwhile?

the techniques of photography. Perhaps the best choice is a camera that has some automatic features, such as **exposure** measurement, yet still has a manual override option. A camera with a **zoom lens**, or interchangeable lenses, gives the greatest scope for learning how to control perspective in pictures (see pp.32-33). Once you are happy with your choice of camera, familiarize yourself thoroughly with all its controls and features. Your best guide for this is the user's manual supplied with the camera. You can learn a lot from this before you even load film. Accessories can figure heavily in some people's minds, but most photographers find the essentials to be a tripod, flashgun, and some form of lens attachment for close-up shots. A camera bag is also useful (see p.17), but you may find that a lightweight, weatherproof jacket, with ample pockets for film, flash, and small accessories, is a convenient alternative.

SHUTTER SPEED

Use a slow **shutter speed** to photograph a fast-moving subject, and your picture could look something like this. Although it is not sharp, the image is evocative of movement and action – which may be more effective than one in which detail is pin-sharp (see p.12). To make this choice, however, your camera must have manually set shutter speeds or an override option.

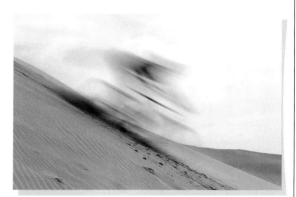

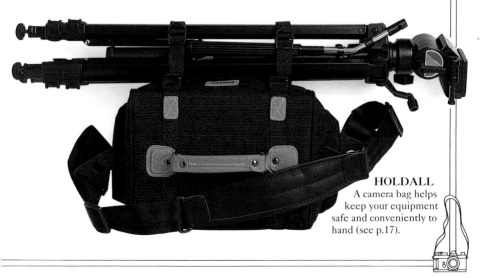

HOLDALL

A camera bag helps keep your equipment safe and conveniently to hand (see p.17).

CAMERA DESIGN

Understanding the basic design differences

CAMERAS THAT USE 35mm-wide, double-perforated film are known as 35mm cameras. It is easier to understand the differences between the various models if you divide them into two types – most are either of the single lens reflex (**SLR**) or compact design.

SINGLE LENS REFLEX DESIGN

A mirror behind the lens reflects the image up to the focusing screen (below left), which also shows precise framing. The pentaprism corrects the mirror image, so that the subject is properly oriented. Pressing the release flips up the mirror and opens the shutter (below right).

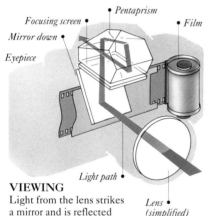

Focusing screen • • *Pentaprism*
Mirror down • • *Film*
Eyepiece
Light path •

VIEWING
Light from the lens strikes a mirror and is reflected up to the focusing screen.
Lens •
(simplified)

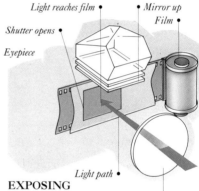

Light reaches film • • *Mirror up*
Shutter opens • *Film •*
Eyepiece
Light path •

EXPOSING
Pressing the release flips the mirror up and opens the shutter to expose the film.
Lens •
(simplified)

COMPACT DESIGN

Compacts have a viewfinder window above the lens, connected directly to the rear eyepiece. This design makes a pentaprism unnecessary. Looking through the eyepiece, the image always appears sharp. Pressing the shutter button opens a shutter set within the lens and allows light to pass through to expose the film.

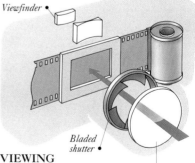

Viewfinder •

Bladed shutter •

VIEWING
With compacts, you do not view quite the same scene as the lens.
• Lens
(simplified)

COMPACT CONTROLS

Most compact cameras automatically measure light for **exposure**, and the subject distance for focusing. There are usually, however, some manual override options. You cannot remove the lens, but many models do have different **focal length** settings. This is achieved with a continuous **zoom**, or a "stepped" zoom with a number of pre-set focal lengths.

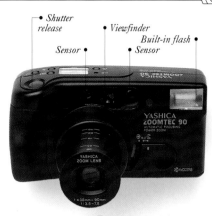

• *Shutter release*
• *Viewfinder*
Sensor •
• *Built-in flash*
• *Sensor*

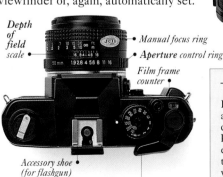

Take-up spool (for exposed film) •
• *Film pressure plate*
• **Zoom** *control switch*
• *DX film-speed sensors*
• *Film cassette compartment*
• *Film check window (shows film data printed on cassette)*

SLR CONTROLS

Focusing is achieved by rotating the focus ring, or it may be automatically set by the camera. **Exposure** is measured from light entering the lens, and adjustments are shown inside the viewfinder or, again, automatically set.

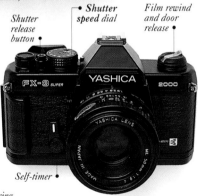

Shutter release button •
• **Shutter speed** *dial*
Film rewind and door release
Self-timer •

Depth of field scale •
• *Manual focus ring*
• *Aperture control ring*
Film frame counter •
Accessory shoe (for flashgun) •
Film wind-on lever •

—— FILM LOADING ——

In subdued light, open the camera back and place the cassette in the film chamber. Push the rewind crank down. Pull out enough film to enable it to engage with the take-up spool. Close the back of the camera and manually wind on until the frame counter indicates "1", or press the release to engage the automatic film transport.

CHANGING FOCUS

Focusing determines which part of the image is sharp. Compacts often cannot focus closer than 1m (3ft) because of **parallax** (see box, p.13). SLRs with a 50mm lens will focus as close as 45cm (18in).

AUTOEXPOSURE

Autoexposure (**AE**) measures the light and sets an **aperture** and **shutter speed** to suit the sensitivity of the film. Right: the AE "chose" appropriate settings for these two widely differing scenes.

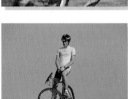
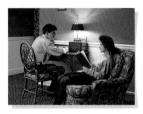

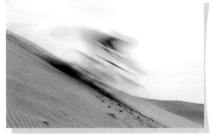
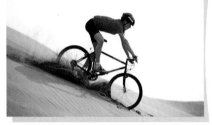

SLOW SHUTTER

A slow **shutter speed** records blur in action shots. It may also give greater **exposure**.

FAST SHUTTER

To "freeze" movement, a fast shutter/wide **aperture** combination was used here.

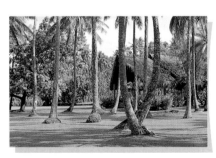

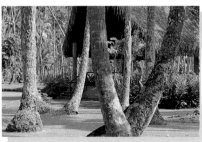

FOCAL LENGTH

Changing lenses on an **SLR** camera, or using the **zoom** control on a compact, will either reduce or enlarge subject detail without you changing camera position. The longer the **focal length**, the larger subject detail looks, but the less of it you can include in the frame. The results here were all shot from the same camera position using the 35mm (above left), 50mm (above), and 80mm (left) lens settings on a zoom-lens compact.

APERTURE EFFECTS

Right: Small **apertures** give more **depth of field** – the range of subject distances that appear sharp – than wide apertures. The extent of the depth of field, though, also depends on lens **focal length** and subject distance from the camera. Aperture settings have "**f-numbers**". The higher the f-number, the smaller the aperture. In these pictures, the first (right) was taken at f2 and the second (far right) at f16. The size of the aperture used also helps to determine film **exposure**.

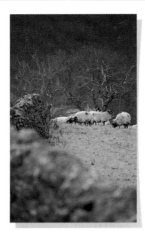
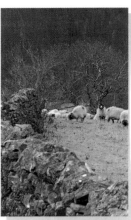

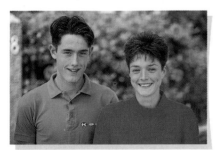

AUTOFOCUS LOCK

Many compacts and **SLR**s feature autofocus (**AF**). Operating the AF sets the lens for anything positioned in a rectangular area in the middle of the viewfinder. In the first picture (above left), the AF focused incorrectly on the background between the subjects. In the next shot (above), the woman was positioned centrally and the focus setting was locked into the camera. The shot was recomposed (left) and the result was correctly focused.

PARALLAX ERROR

Parallax error is a problem that applies only to compact cameras. This is due to the fact that the viewfinder shows the subject from a viewpoint that is slightly different from that encompassed by the lens (see p.10). The frame shape in the viewfinder contains marks showing the true picture limits. You must, therefore, take care to compose your subject within these marks, especially when working at close subject distances.

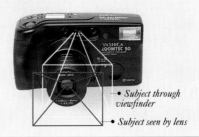

• *Subject through viewfinder*

• *Subject seen by lens*

WHICH CAMERA?

Determine your priorities, then choose the best camera for the job

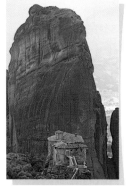

LONG DISTANCE
Long focus lens shot. Use camera 2 at 90mm, or 3 or 4 with a **telephoto lens**.

THERE IS no ideal camera. For point-and-shoot photography, a compact is a good choice; for close-up work or natural history, you will need an **SLR**. You could decide on a top-of-the-range model, since there are few situations it would not be able to cope with. However, these cameras often bristle with controls and **exposure-** and focus-mode options that are confusing if not used frequently. You might opt instead for a camera with fully automatic settings, but suitable really only for general subjects. As a guide, look at the cameras below right, which have been considered against the range of subjects illustrated here.

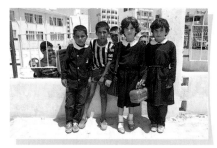

EXPOSURE OVERRIDE
Manual **exposure or** override facility is needed here to prevent **underexposing** figures. Use camera types 3 and 4.

CLOSE FOCUSING
These roses are within the focusing range of 2, 3, and 4, but 3 and 4 have wider **apertures** for dim light and no **parallax** problems.

QUICK SHOTS
AF is a help here. Use camera 2 at maximum **zoom**, or 4 with a **telephoto lens**.

DIM LIGHT
This shot taken in dim light is easier with the wide **aperture** and **AF** of camera 4.

INTERIORS
A slow **shutter** and a **wide-angle** are needed. Use 2, or 3 and 4 with a wide-angle.

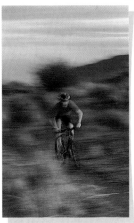

FREEZING ACTION
The ½₀₀₀ **shutter speed** that is needed here necessitates the use of camera 3 or 4.

PORTRAIT
This is best with bounced flash, so use camera 3 or 4 with a swivel-head flashgun.

ACTION BLUR
For action-blur you need control over the shutter. Use camera 3 or 4 for best results.

CAMERA TYPES

To help your choice, look at the technical details accompanying the cameras below in relation to the information given with each picture.

1. BASIC COMPACT
A point-and-shoot autofocus, fixed **focal length** compact with an f3.5, 32mm lens. **Exposure** settings are automatic-only.

2. ADVANCED COMPACT
This compact has an f3.5, 38-90mm lens plus macro-focusing. It has **AF** and **AE**, with a wider range of **shutter speeds** than camera 1.

3. BASIC SLR
Costing about the same as a good compact, this **SLR** has an f1.9, 50mm interchangeable lens. **Exposure** and focusing are manual.

4. ADVANCED SLR
Three times the price of 3, this model has an f1.8, 50mm lens, **AF**, **AE**, manual overrides, and built-in flash and **motordrive**.

CAMERA ACCESSORIES

Work out your priorities before buying any photographic extras

A COMPACT CAMERA with a **zoom** lens and a built-in flash requires very few extras. With an **SLR**, however, you can choose from many accessories that allow a wide range of results, or from ones that ideally suit your preferred subjects and methods of shooting. For example, if your interest lies in sports or nature photography, you could fit a **telephoto** to the camera to magnify distant subjects.

MAKING A CHOICE

If you intend to do a lot of indoor work, then a flashgun and tripod may be a priority. If you want maximum flexibility of **focal length**, without being weighed down by equipment, then you should consider a **zoom**.

LENS TRIPOD MOUNT •
With a heavy lens, a tripod mounting ring is always fitted. If mounted normally, the weight of the lens would place too much strain on the lens/ body connection.

FLASH CONNECTION •
The flash unit (shown below right) fits on to the camera here.

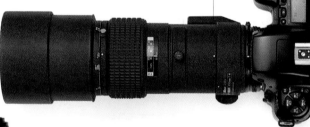

TELEPHOTO
A 300mm lens or longer magnifies distant subjects. This is ideal for sport, candid, or natural history photography.

24mm

28mm

50mm

70-210mm

LENS RANGE
A "normal", or standard, lens for a 35mm camera is 50mm. Shorter **focal length** lenses are known as **wide-angles**, and longer types **telephotos**. **Zoom lenses** can cross the boundary between the two.

85mm

28-70mm

CARRYALL BAGS

Once accessories start accumulating, you will soon need a carryall bag. A weatherproof, padded bag protects your camera, has pockets for small items, and allows easy access to equipment.

• COMPARTMENTS
Internal compartments are adjustable. For example, you might want to make this compartment larger and keep your most-used lens attached to the camera body. Always carry spare lenses with their front and back caps fitted.

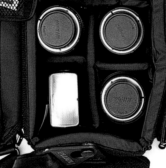

• SIDE PANEL
Small items, such as a cable release and brush, fit here.

POUCHES •
Pouches inside the lid are ideal for exposed and unexposed film.

• VITAL EXTRAS
Always carry spare flash and camera batteries, and a few of the **filters** you find most useful.

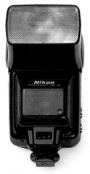

FLASH
This unit fits into the **SLR**'s accessory shoe, or attaches to the camera by a special cable.

RIGID CAMERA CASES

WHAT ARE THEY?
Some photographers prefer rigid camera cases to soft holdall bags. These look like small, silver-colored suitcases and they are usually made of solid aluminium or aluminium-covered cardboard. Inside the case there is a solid block of high-density foam, out of which you must cut holes to fit the exact shapes of your equipment and all your accessories.

PROS
Rigid cases offer greater protection from the elements and from bangs and knocks, and you may be able to stand on them for height while shooting.

CONS
Good-quality ones are expensive and are heavy to carry. You will also need a selection of foam inserts for different combinations of equip-ment and accessories.

WHICH FILM?

For the best results, use the most appropriate film

BOTH 35MM SLRS AND COMPACTS use the same film. So, your choice of film type depends on whether you want a print or a slide in color or in black and white; your personal preference for brand; and whether subject conditions are dim and call for a "fast" film, or bright and a "slow" film would be adequate.

FILM TYPES

There are three main films – black and white negative, color slide, and color negative. Color prints can be made from slides as well as from negatives.

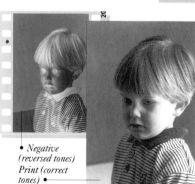

Plastic slide mount •

Unmounted slide •

COLOR SLIDES
Slide films give the best-quality images, but each one needs to be mounted and projected. Different emulsions are made for daylight/flash exposure and **incandescent** light. Color and black and white prints can be made from slides, but this is expensive.

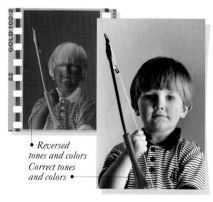

• Negative
(reversed tones)
Print (correct
tones) •

• Reversed
tones and colors
Correct tones
and colors •

BLACK AND WHITE NEGATIVES
This film produces the best-quality black and white prints, although few stores offer a range of films or processing services.

COLOR NEGATIVES
These produce inexpensive, good-quality prints, but negative colors are reversed and difficult to assess before seeing the print.

BRAND BIAS

The dyes in films and papers vary according to brand. A scene on, say, Fuji film will differ from results on Kodak. Individual results from either may look excellent, but for sequences use the same film and paper stock.

COMPARISONS
Right: Differences show up mostly in neutral hues, such as the backgrounds and skin tones in these two pictures. Some brands are biased towards blue, others towards green. Choice is mainly a matter of personal preference.

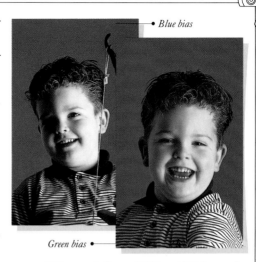

• *Blue bias*

Green bias •

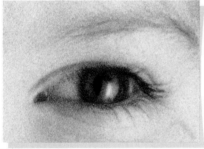

FAST FILM
Above: In this x20 enlargement from **ISO** 1600 film, coarse **grain** is clear. However, this film allows faster **shutter speeds** or smaller **apertures** in dim lighting.

SLOW FILM
Right: This is a similar enlargement from **ISO** 100 film showing little **grain**. Slow film allows longer **exposures** or wider **apertures**, and is ideal when light levels are high.

FILM SPEED

Films have a rating indicating their relative sensitivity to light. **ISO** 400 films are twice as "fast" as ISO 200 ones, and so on. Use fast films in dim lighting or when brief **shutter speeds** are needed. Results are, however, **grainier** than with slow films, a factor that can be used creatively.

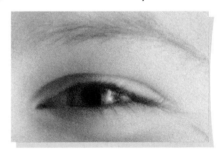

DX FILM SPEEDS

On a 35mm cassette, the **ISO** film speed is encoded as a pattern of squares. These squares either make or break contact with a row of electronic sensors in the film compartment of most modern **SLR** and compact cameras, automatically setting the camera's light-metering circuit for that particular speed of film. This is known as **DX film-speed** recognition.

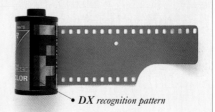

• *DX recognition pattern*

CAMERA & EYE

The camera does not record the scene quite as it appears to the eye

LIKE A CAMERA, your eye has a lens that forms an image on a light-sensitive surface, known as the retina. However, a photograph differs considerably from the way the subject looks to the eye. A scene that is viewed by the eye has only vaguely defined edges (right). In comparison, a photograph has set corners and edges (inset right) that must be used as limits to your picture composition.

Ill-defined edges seen by eye •
Clear-cut edges of picture extent •

SUBJECT CONDITIONS

Your eye is capable of seeing detail in both shadowy and brightly lit surfaces of the same subject. In identical conditions, film cannot record both at the same settings. Film also records subject color according to the color of the light illuminating it. The eye makes allowances for this, however, and a white object under yellowish light is still seen as being white.

EVEN LIGHTING
When lighting is even, an **exposure** reading taken from anywhere on the subject will do.

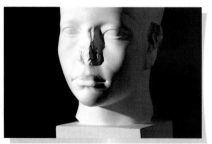

HIGHLIGHT READING
With directional lighting, a reading taken from the lit side **underexposes** the shadows.

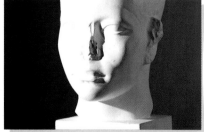

SHADOW READING
With the lighting unchanged, a reading from the shadow side **overexposes** the **highlights**.

COLOR CASTS

Color casts can appear on pictures for many reasons, most commonly taking pictures indoors by **incandescent** light on film meant to be exposed by daylight or flash. Processing errors and vividly colored surroundings can cause an unexpected cast.

MIXED LIGHTING

Interiors are often lit partly by daylight and partly by **incandescent** or fluorescent. The eye accepts these as "white" light. Film does not and is usually balanced to record sunlit or flashlit objects correctly. This film will reproduce incandescent light as orange and fluorescent as green unless **filters** are used.

COLORED SURROUNDINGS

Nearby colored surroundings can tint the lighting on your subject, producing a color cast on prints. In this shot, a blue wall behind and to the right of the figure gives a cold cast. Your eye may accept this distortion, but it looks odd in a photograph. If possible, move your subject away from such surroundings.

PRINTING FAULTS

PRINT PROCESSORS

Some color casts have nothing to do with you failing to foresee a problem, and stem solely from the printing process. Incorrect assessment by the print processing machines, most of which are fully automatic, may result in an image with very odd colors.

REPRINTS

This picture contains about 80 per cent of blue sky, and only 20 per cent or less of important skin tones. The processor overcompensated for the large area of blue sky and so produced skin tones that are distinctly yellow. Ask for a reprint if your negative (and other prints on the same roll) looks normal.

• *A large area of dominant color, such as an expanse of sky, can be a source of processing problems*

• *Skin tones will readily show up any problems in the processing and printing*

THE WEEKEND COURSE

Experimentation and trial and error are the keys to success

THIS COURSE is divided into 13 skills. Skills 1-7 are basic, designed to teach you how to achieve specific results. With skills 8-13 you start to apply the basics to a range of subjects. It is important to see results before progressing further, and using 24-exposure rolls means that you will get film off to the processors more frequently. In general, work with **ISO** 200 color film, with some ISO 100 film for recording blur, and ISO 400 or faster for "frozen" action, and dim lighting.

Using your body as a support (p.24)

Bellows for detailed close-ups (p.70)

DAY 1		Hours	Page
SKILL 1	Holding still	$^1/_2$	24
SKILL 2	Shot framing	$^1/_2$	26
SKILL 3	Viewpoints	1	28
SKILL 4	Emphasis	2	34
SKILL 5	Tone & color	1	40
SKILL 6	Using light	2	42
SKILL 7	Using flash	$1^1/_2$	50

A lightweight monopod (p.25)

KEY TO SYMBOLS

CLOCKS

Small clock symbols appear on the first page of each skill. The blue segment shows how long you should spend on that skill. For example, the blue segment of the clock on page 28 indicates that you should set aside 60 minutes for Skill 3, while the grey segment shows that 30 minutes were recommended for the previous skill. In some instances you will need to adapt these skill time recommendations. Skill 6 on page 42, for example, should take you 2 hours in total, but you will need to spread this over an 8-hour period since you will have to wait for the sun to move before taking some of the photographs.

RATING SYSTEM •••••

Each skill has a difficulty rating, from one bullet (•) for the simple, straightforward skills, to five bullets for the more challenging ones.

Tripods come in many sizes (p.25)

Lenses for flexibility (p.16)

Exposure *for atmosphere (p.41)*

DAY 2		Hours	Page
SKILL 8	People shots	2	56
SKILL 9	Landscapes	1½	60
SKILL 10	Interiors	1	64
SKILL 11	Action shots	1½	66
SKILL 12	Close-ups	1	70
SKILL 13	After dark	1½	74

The top plate of a modern SLR (p.15)

A monopod helps stabilize the camera (p.25)

1 HOLDING STILL

DAY 1

Definition: *Avoiding unwanted, image-impairing blur*

NO MATTER WHAT CAMERA you use, dim light or slow film may make slow **shutter speeds** necessary, and the risk of camera shake also increases with the **focal length** of the lens. Instead of hand-holding the camera, you can use some of the supports shown here.

OBJECTIVE: To minimize the effects of camera shake. *Rating •*

TYPES OF SUPPORT

Blur-free photographs at **shutter speeds** of about $\frac{1}{60}$ are possible if you hold the camera properly, and the lens is not too heavy. At slower speeds, or when using a heavy **telephoto lens**, choose between a hand-held or freestanding support.

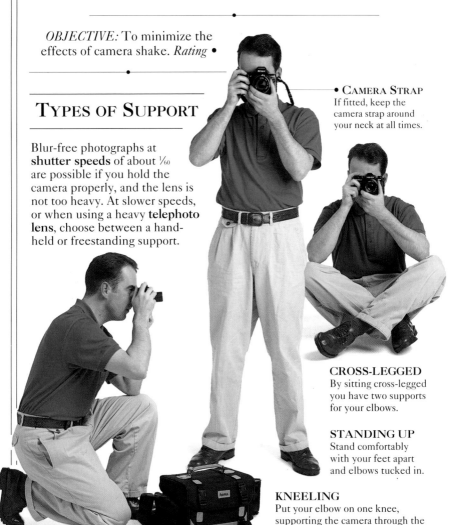

• CAMERA STRAP
If fitted, keep the camera strap around your neck at all times.

CROSS-LEGGED
By sitting cross-legged you have two supports for your elbows.

STANDING UP
Stand comfortably with your feet apart and elbows tucked in.

KNEELING
Put your elbow on one knee, supporting the camera through the arm and lower leg to the ground.

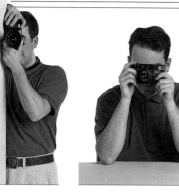

WALL
Press the camera against a solid surface.

TABLE
Sit comfortably with your elbows resting on a stable surface, such as a table.

RELEASE

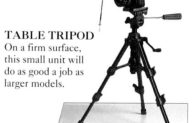

Steadying the camera is pointless if you then jog it when releasing the shutter. To avoid this, use a mechanical or electrical release (if your camera accepts one). If not, support the camera on a tripod, monopod, or clamp, or rest it on a flat surface and use the delayed action. Any vibration will stop before the shutter fires.

PRONE
Lying face down, support the camera on your camera bag, or a similar item.

Cable release •

TABLE TRIPOD
On a firm surface, this small unit will do as good a job as larger models.

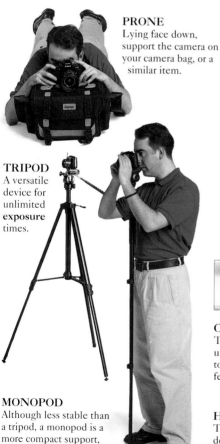

TRIPOD
A versatile device for unlimited **exposure** times.

Cable release •

CLAMP
This small unit attaches to any handy fence or shelf.

MONOPOD
Although less stable than a tripod, a monopod is a more compact support, useful when space is tight or when in crowds.

HAND GRIP
This compact device has a trigger in the handle to fire the shutter.

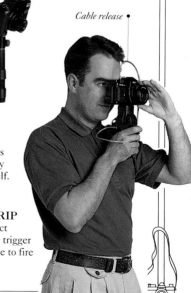

2 SHOT FRAMING

Definition: *Using the viewfinder to best effect*

TRY TO THINK of the rectangular "frame" you see through the viewfinder as a pad of paper on which you can compose a picture. The many ways that you can use it to enclose just part of the image in front of you open up a world of picture-making possibilities.

OBJECTIVE: To increase awareness of picture composition. *Rating* ••

WHAT TO INCLUDE?

Before you press the shutter release, use the viewfinder image to evaluate which elements of the scene you wish to photograph work best together. Alter the camera position to frame and isolate these elements and produce the best possible effect.

Fore- and background are related using vertical framing

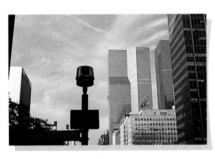

Horizontal framing imparts a sense of "flow"

A square exerts least effect on composition

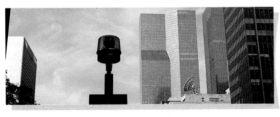

Unusual framing is possible by cropping with scissors

1. CROPPING

Experiment with framing to learn how it affects the image. Squaring up a vertical shot (above), loses much of the dynamism of the picture. In the horizontal versions (left), there is a greater feeling of movement and "flow" across the frame.

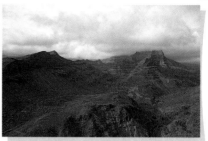

2. LOW HORIZON
Try positioning strong picture divisions, such as the horizon, at different levels in the shot. Tilt the camera up, to move the horizon lower. This produces a more open look to the scene and gives an impression of distance.

3. HIGH HORIZON
Introduce a more enclosed feeling to the scene by tilting the camera down. This position has the effect of emphasizing the land, so, to be a really successful shot, the landscape must be full of interest and detail.

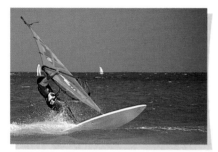

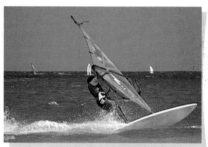

4. ACTION INTO THE FRAME
Use appropriate framing to strengthen your pictures of moving subjects. Position the action to the far left of the viewfinder; by showing that there is space to move into, you imply there is plenty of action still to come.

5. ACTION OUT OF THE FRAME
Positioning the subject closer to the right of the frame, however, implies that some action has already taken place. Both types of framing (above and above left) avoid the monotony of placing everything dead center.

"INTERSECTION OF THIRDS"

Imagine that the viewfinder is divided into thirds by horizontal and vertical lines. Where the lines intersect you get four off-center points. This idea is known as the "intersection of thirds", and any of these points is a strong potential position for your main subject.

Imaginary horizontal line •

The fisherman's body •
occupies two intersections

Imaginary vertical line •

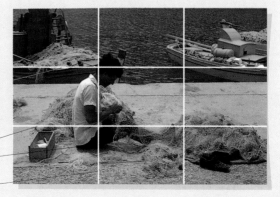

3 VIEWPOINTS

Definition: *Deciding the best camera position for the subject*

IT IS TEMPTING to take your photographs from whatever position happens to be most convenient. However, thinking carefully about camera position can make huge differences to both foreground and background content and how these relate, as well as to perspective. It is perspective, in fact, that imparts that important sense of depth and distance to the two-dimensional picture.

OBJECTIVE: To explore the effects of viewpoint. *Rating* •••

FRAME FILLING

When deciding on your viewpoint ensure that your subject is large in relation to its surroundings. If it seems too small, move forward, keeping within the camera's focusing range; or try making the subject larger by using a **telephoto** setting. Bear in mind that a telephoto does not always give the feeling of "closeness" you get by moving nearer and using a shorter lens.

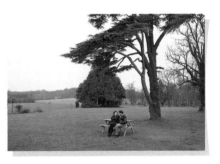

1. DISTANT VIEWPOINT
Look at a distant subject through the camera viewfinder. Does it appear, as the subjects here, just an insignificant part of the scene?

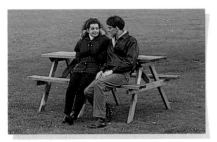

2. CHANGING TO TELEPHOTO
Remain in the same position as **1**, but change to a longer **focal length** to bring the subjects up in size. Here the lens has also enlarged and simplified the background.

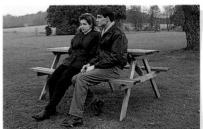

3. CLOSER VIEWPOINT
Use the same lens as **1**, but now move closer to the subjects to make them about the same size as in the last shot (**2**). Note how the background has opened out again.

FOREGROUND AND BACKGROUND

Choose your viewpoint carefully and you may be able to combine near and far parts of the scene. These will enhance the sense of place. They can also help to fill up the frame if the subject is small. Use this technique to create a sense of depth and distance (see pp.32-33).

1. LACK OF EMPHASIS
Consider a scene as it appears naturally – this house, positioned in an empty landscape, lacks interest. Now, shift your view to find other ways of emphasizing the elements.

2. FRAMES WITHIN FRAMES
By altering your position slightly, look to see how to introduce foreground interest. In this shot, a break in the foliage forms a natural frame in which to set the subject.

FALSE ATTACHMENT

When one part of the subject is shown overlapping another, so that they appear to be joined, the effect is known as "false attachment". This can be destructive, such as a pole seeming to grow out of a person's head. However, by thinking about the viewpoint, you may be able to join lines or shapes within the image to create a unity that would not otherwise exist.

Once you understand it, you can use false attachment, as here, to introduce a humorous element •

SKILL

3

TRYING THE ANGLES

Explore the way shooting position affects the relationship of objects in the fore-, middle-, and background. Find a setting with a prominent main subject, plus static objects both closer and farther away. Ensure these elements create a scene with a richly detailed foreground and background. You could try a person in a street scene, a garden, or even a large, evenly lit room. The exact relationship of foreground, subject, and background will change every time you change the camera's viewpoint. Aim to produce a set of photographs with as many variations as possible.

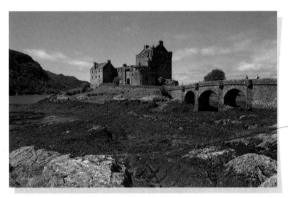

1. THE SETTING

Take an overview of your choosen scene. This Scottish castle is seen from the south-east. A **wide-angle lens** emphasizes its powerful form dominating the horizon.

• NATURAL FEATURES

The curve of this foreground helps to produce an enclosed feeling, enveloping the rest of the scene. Good **depth of field** reveals detail throughout.

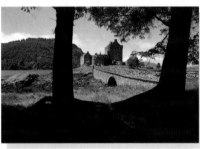

A strong foreground

A confined atmosphere

2. LOW VIEWPOINTS

Above: Lower the camera to introduce new foreground elements. In the version above left, trees firmly establish the foreground, while making a frame within which to set the castle. In the next photograph (above right), the gates fulfil a similar function.

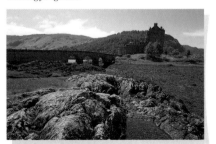

Controlling the composition

3. LEAD-IN LINES

Left: Look for existing features to exploit as part of the composition. In this shot, the approach road provides a natural lead-in line, taking the eye towards the main subject.

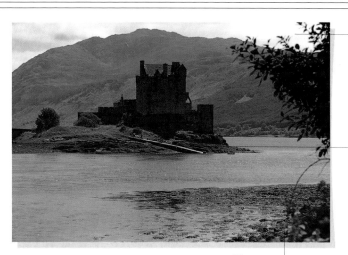

• EXPOSURE
Shooting against
the light, as here,
can cause the
meter to make
the main subject
too dark.

• HIGHLIGHT
This bright
highlight helps
to prevent the
image appearing
flat and lacking
in **contrast**.

4. HAZY LIGHT
Try taking a shot that is almost against the
light, with the sun more directly overhead.

FOLIAGE •
This close foliage helps to
add depth and distance.

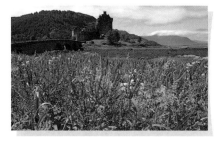

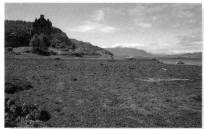

5. GROUND LEVEL
Experiment with a shot at ground level. For
strong foreground elements, such as these
reeds, an **SLR** ensures accuracy in relating
them to the rest of the scene (see pp.14-15).

6. HIGHER VIEWPOINT
Raise the level of the camera and move a few
paces farther around the subject, perhaps to
introduce a change of foreground or even
entirely alter the compostion of the image.

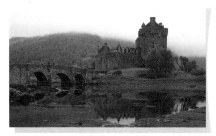

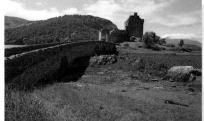

7. REFLECTIONS
Look for added interest. Here, an expanse of
still water provides a reflective foreground.
It completes circles under the arches of the
bridge and repeats some of the castle skyline.

8. CHANGING PERCEPTIONS
Move away from the subject for one of your
shots. Still taken from the north, but farther
back and closer to the bridge, the castle here
no longer appears to be cut off by water.

SKILL

3 PERSPECTIVE

Learn how to exploit the effects of perspective, which affects the scale and appearance of objects nearest in the picture in relation to those farther away. A photograph with foreground objects abnormally large and details in the background abnormally small is said to have "steep" perspective. "Flattened" perspective occurs when near and far parts of a scene differ little in scale. Try controlling this by changing both the subject-to-camera distance and lens **focal length**.

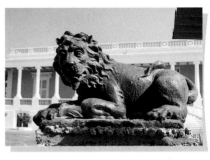

1. NORMAL PERSPECTIVE
First, try taking a photograph that shows perspective as realistic and natural. This picture was taken with a 50mm lens. Note the columns in the background building for comparison with the two photographs below.

2. STEEP PERSPECTIVE
Next, try to show steep perspective. Here, the original distance between the camera and lion was halved, making the lion appear larger in relation to the building, and lens was changed to 28mm to include the whole lion again.

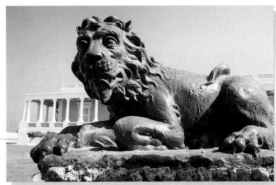

BACKGROUND •
Notice the reduced size of the background building in relation to the lion.

3. FLAT PERSPECTIVE
Now, using a **telephoto**, move well back until you are farther from the subject than in the first version (**1**). Adjust your distance until the subject is the same size in the frame as in the previous shots. This will flatten perspective.

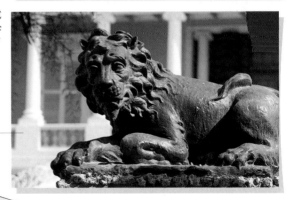

BACKGROUND •
Building detail is unnaturally enlarged, reducing the sense of depth and distance in the shot.

LENS EFFECTS
Right: As here, a close viewpoint and a 28mm lens includes many columns. A 135mm lens used farther back sees fewer columns.

28mm lens, close to

135mm lens, farther back

DESTRUCTIVE PERSPECTIVE

WRONG
For a portrait, if you move in with a normal or **wide-angle lens** you create a destructive perspective (near right). Note the large nose and lack of ears.

RIGHT
Use a **long lens** from farther back for better results (far right). For 35mm cameras, an 80-90mm lens is an ideal **focal length** for portraits.

HINT
With a fixed **wide-angle**, take a half-length shot and have the picture enlarged.

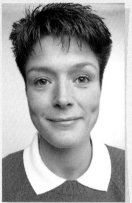 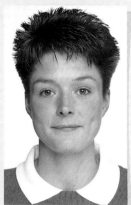

35mm lens, 50cm (20in) from face *80mm lens, 1m (3ft) from face*

4. USING PERSPECTIVE
Once you know how it works, use perspective to add drama, taking care that it does not produce too much distortion. Choose a view, such as this, where steep perspective adds to the impression of depth and distance, enlarging close detail and diminishing the figures farthest away. Here, a 28mm lens was used to achieve this effect. **Exposure** in the dim light was ⅕s at f8. The **depth of field** that is offered by the **wide-angle** is noticeable in the almost complete overall sharpness of the image.

BLURRING •
The slight blurring of the moving figures caused by the slow **shutter speed** adds to the sense of a vortex.

CORNER DISTORTION •
With most lenses, distortion is likeliest in the picture corners. Avoid placing important image detail there.

4 EMPHASIS

Definition: *Isolating and emphasizing your chosen subject*

YOUR EYE IS SELECTIVE, only picking out detail that interests you. A camera, however, records everything along with the subject. Therefore, it is necessary to create emphasis and direct the viewer to the picture's main feature. One way is to make this feature the only correctly exposed one in shot, another is to control focus and blur.

OBJECTIVE: To use the camera's controls to interpret a scene. *Rating* ••••

LIGHT AND EXPOSURE

Experiment with settings to learn how to use lighting for emphasis. Choose a subject that is either lit more strongly than the rest of the scene, or one that is the only feature in shadow. Set **exposure** for the subject alone and the rest of picture will be either too dark or too light. The effect of this is strongest when lighting **contrasts**. For correct exposure, fill the frame with the critical part of the scene, lock the readings in, or set them manually, move back, and recompose the shot.

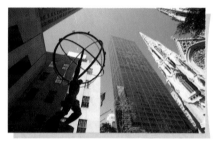

1. GENERAL READING
Pick a scene where lighting **contrasts** and take an overall reading. Your result will show **underexposed** areas, like the statue of Atlas above, and areas that are **overexposed**, like the church façade. A poor compromise.

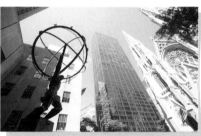

2. SHADOW READING
Next, take a reading from the shadows and lock it in. Here, the camera was brought close to the statue and the **AE** lock used. The shot was recomposed so the statue was correctly exposed. Other elements are **overexposed**.

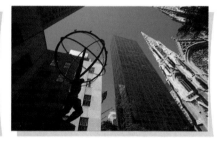

3. HIGHLIGHT READING
Now measure **exposure** solely from a bright part of the scene. Here, the church was used, the **AE** lock was applied, and the picture was recomposed. The church now dominates the scene, reversing the picture emphasis.

FOCUS AND BLUR

The relative sharpness of objects can be used to control emphasis. The subject must be at one distance from the camera, and all distracting detail either closer or farther away. First, focus accurately for the subject, then set a large **aperture** (low **f-number**). This limits **depth of field** (see p.13). If the gap between the subject and the other elements is sufficient, only the specific distance you focus on will have sharp detail. With a wide aperture, **overexposure** is a potential problem, but a slow, **ISO** 100 film (see pp.18-19) should help. Depth of field is shallower, at any aperture setting, the longer the lens (or its **zoom** setting).

BACKGROUND •
Depth of field at f16 extends past the point of actual focus and includes these background features.

MIDDLE GROUND •
The camera lens was focused at about this subject distance from the camera, midway through the scene.

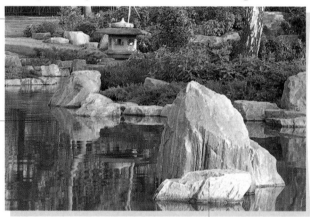

1. NO EMPHASIS
Take a photograph so the whole scene is sharp. This picture, shot at f16, is how the garden would appear to the eye, which adjusts focus as it examines things at different distances. Nothing is emphasized by localized focus.

FOREGROUND •
With the lens set to f16, **depth of field** also extends back towards the camera, and includes this foreground rock.

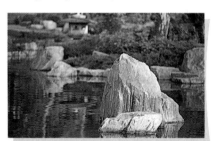

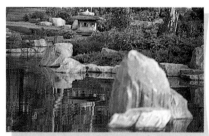

2. EMPHASIZE FOREGROUND
Focus the camera lens on the foreground, in this case the rock. Then change the **aperture** to restrict **depth of field** (here it was set to f3.5). The effect is more three dimensional when it is compared with **1**, above.

3. EMPHASIZE BACKGROUND
This time, focus the lens on the background. Keep the **aperture** the same, so as to limit sharpness and give a soft foreground. Like focus-pulling in a movie, the emphasis is shifted from the fore- to the background.

SKILL

4

STRUCTURE AND CONTRAST

You can give powerful emphasis to the main subject simply by the way you show it against its surroundings. Try making your subject "break" some sort of artificial or natural pattern or structure, or make it stand out from a background contrasting in color or tone. To achieve this, you may have to shift camera position as you monitor the changes in the viewfinder. Learn to recognize the potential in a strong setting, and then shoot with the subject positioned in the most beneficial fashion.

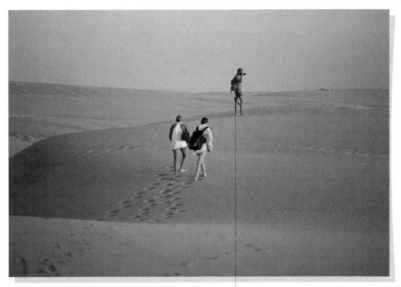

1. BREAKING A LINE
Choose a setting where the elements are emphasized by the way they break natural lines in a landscape. Timing matters as much as framing in this example.

• EMPHASIS
This figure attracts the most attention because it breaks the horizon – the strongest line here owing to differences in color.

2. USING LEAD-INS
Make use of converging lines to lead the eye into a scene. This can be achieved by using a **wide-angle lens** with foreground elements of the scene close to the camera. In this result, the convergent Z-shape of the jetty draws attention to the three white elements in the picture.

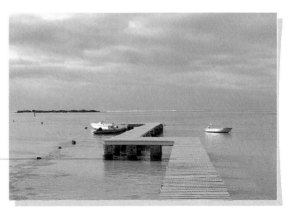

CONVERGENCE •
A low, close camera and **wide-angle** exaggerate convergence in the lines of the jetty.

3. TONAL CONTRAST

Emphasize the main subject by positioning it to contrast with the surrounding tones – light parts against dark or dark against light. The correct **exposure** for your key element is important – see "Light and exposure" p.34. Don't allow the light reading to be influenced by any much larger lighter or darker elements. This picture was shot from street level with a 135mm lens.

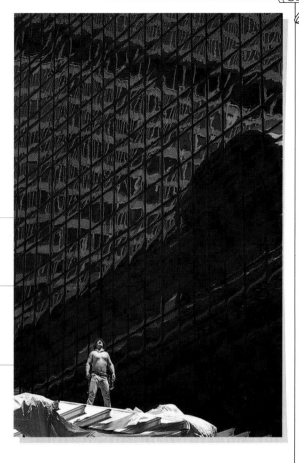

TONAL VALUES •
These reflective building panels are of a significantly darker tone than the construction worker.

EXPOSURE •
Large areas of deep shade made **exposure** for the relatively small, sunlit figure difficult. In situations like this, try **bracketing** exposures.

LENS AND FRAMING •
With the figure framed low by a 135mm **telephoto lens**, the size of the building is greatly exaggerated. This makes it seem closer than it appeared to the naked eye.

4. COLOR CONTRAST

Below: Keep alert for **contrasts** in color. These can help to enliven your results. The red boats in this shot are strongly emphasized when seen against the cooler blues and greens.

• **HAZE**
Blue haze subdues other natural colors present in the scene, giving the boats additional emphasis.

PERSPECTIVE •
Tones tend towards blue as they recede, producing what is known as aerial perspective.

BALANCE •
The red boats on the shore are well balanced by the one at sea.

DARKER FOREGROUND •
Darker tones here help to impart a greater sense of depth and distance to the picture.

4 BLURRING

Emphasizing action through the deliberate use of blur

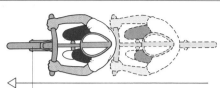

PANNING FOR ACTION

Select a slow **shutter speed** and shoot while moving the camera to follow the subject. The subject will then record on the film as acceptably sharp, while all the static parts of the scene turn into varying degrees of streaks and blurs. This technique is known as panning. It works because the subject, although moving, remains in the same relative position to the camera frame. It is mainly the static parts of the scene that seem to move. Slow film and a small **aperture** may be needed to avoid **overexposing** the image.

• SUBJECT
Direction of travel of subject.

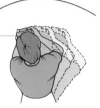

CAMERA •
Move the camera smoothly to follow the subject.

1. PANNING TECHNIQUE
For successful panning, keep the subject centered in the viewfinder for focusing. Pivot your body as you expose, and follow through smoothly after the shutter has closed.

2. SUBJECT CHOICE
Choose a patterned fore- and background – perhaps tree foliage or parked cars. The more patterns the more effective the blur lines. For this shot ⅟₃₀, was set and a 135mm lens used. The **AE** mode was **shutter-priority**.

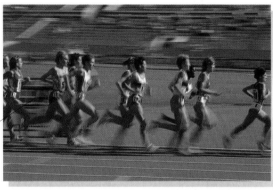

BACKGROUND •
It is these blurred and streaked objects in the background that impart the sense of speed and action.

3. BAD PANNING
Note why this shot is less effective. The athletes are about the same size in the frame as **2** but, they are seen against a plain background, and although the same **shutter speed** was used (⅟₃₀), much of the impact is lost.

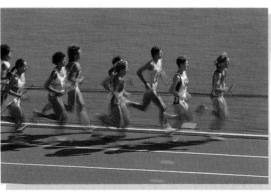

BACKGROUND •
A plain background, such as grass, is not ideal for a panned shot, since it fails to give a feeling of action.

ZOOMING FOR ACTION

For this technique, you need a **zoom lens** that allows a continuous change of **focal length**, rather than a stepped zoom. Position your camera so that it is head-on to the action. Experiment with different **shutter speeds**, such as ¼, ½, and 1 full second, as much depends on the distance of the subject from the camera and the lens focal length. Start zooming just before the shutter opens, and continue steadily throughout the **exposure**.

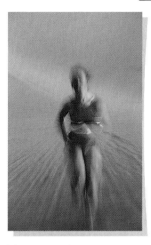

1. SUBJECT SETTING
Position a strong element in center frame since the blur lines will radiate from this point. **Exposure** here was 1 second at f16. A small **aperture** prevented **overexposure**.

A fast zoom produces more streaks

2. TRIAL AND ERROR
Be prepared to use up several **exposures** on a "hit-or-miss" basis in order to achieve a successful result. Before attempting this technique for real, you may benefit from practicing **zooming** the lens with an empty camera. In this shot, which has the same exposure settings as **1**, sidelighting has helped to create areas of **highlight** and shadow, which translate into a mix of dark and light blur lines.

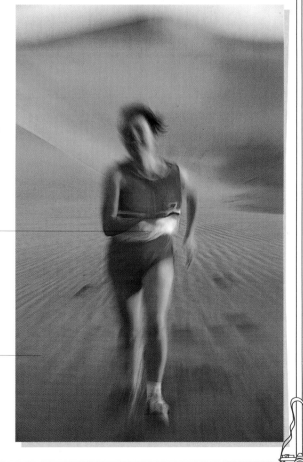

HIGHLIGHTS •
The lighter and white parts of the clothing worn by the athlete spread out and record much more of the movement than the more shadowy elements of the image.

PICTURE EDGES •
Notice how the blur is more pronounced towards the picture corners and edges. A plain background avoids excessive confusion between the subject and its surroundings.

5

TONE & COLOR

Definition: *Using tone and color to strengthen mood*

USING DISCORDANT OR HARMONIOUS colors, or making pictures darker or lighter than is "correct", can help the mood of a shot. The effect of dark tones is often somber; pale tones are more delicate.

OBJECTIVE: To control picture mood by tone and color. *Rating* ••••

COLOR INFLUENCES

Try altering the mood of a photograph by using color in different ways. We associate orange and yellow, for example, with "warmth", whereas blue and green colors are thought of as "cool". A good way to control color is by selectivity – your grouping of objects in the viewfinder. The warmth of a cottage interior, for example, or the cold grey of granite stem from the dominant colors of the scene.

COLOR BALANCE
Right: Color negatives are balanced to give correct colors for subjects lit by daylight or flash. In pictures lit by household lamps (near right) expect an orange color cast, unless corrected during printing (far right).

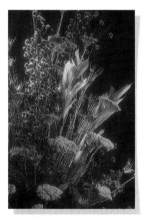

1. WARM COLORS
For a warm effect, choose elements in a limited range of sunny colors, such as these dried flowers. Here, an orange lens **filter** was used to strengthen the mood.

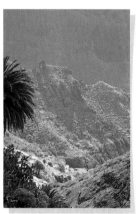

2. COOL COLORS
Use the other end of the color spectrum for a cool, receding effect. This moody landscape of greens and blues was taken without lens **filters** on a hazy day.

Subject lit by household bulbs

Corrected print

TONAL CONTROL

Try experimenting with lightening or darkening tone to enhance the mood of a picture. Give a little more **exposure** (see **2**, right) or less exposure (see **4**, below). Printing exerts a great influence, so you may be able to achieve the results you want simply by specifying a lighter or darker print from a normal negative.

1. "CORRECT"
A normal **exposure** gives muddy skin tones and too much background tone.

2. "OVEREXPOSED"
Overexposing for a lighter print cleans up tones and gives a more delicate image.

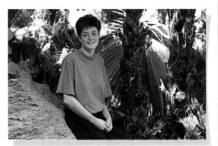

3. "CORRECT"
The trees surrounding the subject mean the light meter "reads" for the shadows and sets an **exposure** that weakens the mood by recording too much detail and information.

4. "UNDEREXPOSED"
Setting one stop less **exposure** may achieve a result that better suits the scene. In this version there is more of a sense of intimacy, and colors are richer and more saturated.

EXPOSURES FOR MOOD

ADVANCING A SUNSET
With a subject of many **contrasts**, such as this seascape, a whole range of **exposures** is possible. Each one produces a different mood. The less exposure you give, the darker and more somber the look and the richer the colors in lightest parts of the scene. Take several pictures in quick succession at different exposures to make a sunset seem to pass through all its stages.

¹/₁₅ at f11

¹/₆₀ at f11

¹/₂₅₀ at f11

SKILL

6 USING LIGHT

Definition: *How lighting affects subject appearance*

PHOTOGRAPHY HELPS to make you more aware of natural lighting conditions and how these can transform a scene. Just a few seconds between shots can make a world of difference if, for example, the first is taken by the even, diffused light from an overcast sky, while the second benefits from a beam of sunshine breaking through the cloud and illuminating some prominent feature in the scene.

OBJECTIVE: To understand the cause and effect of lighting. *Rating* •••

HARD OR SOFT LIGHTING

Be aware of the effects lighting quality has on your photographs. "Hard" lighting, from a compact source – the sun in a clear sky, or, indoors, light from a small window – forms hard-edged shadows. "Soft" lighting, from a large area source – a cloudy sky or a large window covered with material such as curtains – produces ill-defined shadows.

• FORM AND TEXTURE
Hard, direct sunlight from one side enhances the form and texture of these flower petals. A similar result is possible with off-camera flash.

• STRUCTURE
With the sun obscured by cloud, texture is now suppressed but the pollen-laden stamens stand out much more clearly.

1. HARD SHADOWS
Above: Here, **exposure** was measured from close-up in direct light. The camera was hand held at ¹⁄₁₂₅, and the **AE** system set f16.

2. SOFT SHADOWS
Right: In diffused light, the **AE** opened up to f5.6, shadows are softer. **Depth of field** is much reduced, the image is less defined.

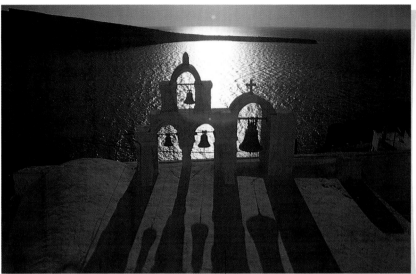

3. SHADOWS FOR STRUCTURE

Shadows can be important picture elements. Here, the bell-tower's shadow, fills more of the image area than the bell-tower itself.

• SHADOW LENGTH

Shadow length depends on the height of the sun. A setting sun casts longer shadows than at noon.

4. MAKE A CHOICE

Right: Use your judgement and always be prepared to experiment to find the most effective type of lighting for your interpretation of the subject. To help you, think about its overall features: is it rounded or angular, textured or smooth, absorbent or reflective? How, too, do you want to record it. Subject qualities of roundness and texture, for example, are best brought out by diffused light from above or to one side (far right); flat-on, hard light (near right) gives you more detail but will destroy form.

Hard frontal light gives detail

Soft sidelight enhances form

LIGHTING COMPLEX SUBJECTS

In general, when you shoot a complicated subject composed of many surface planes at different angles, soft lighting usually gives the best results. Otherwise, shadows produced from hard light easily confuse the detail of objects in the picture and the result will probably be muddled. This is especially true of group shots (see pp.58-59) where people's shadows may be cast on other people's faces obscuring important subject detail. However, hard lighting and dominant shadows are useful to transform an object, hiding detail and forming a type of abstract imagery.

SKILL

6

LIGHTING DIRECTION

The direction from which light strikes the subject determines which parts are lit, and therefore emphasized, and which are subdued in shadow. When the subject is fixed – a building or a landscape feature, for example – shoot when the direction of light best suits the camera viewpoint you have chosen (see p.28). Since the sun moves in a predictable arc through the sky, try to anticipate when that might be.

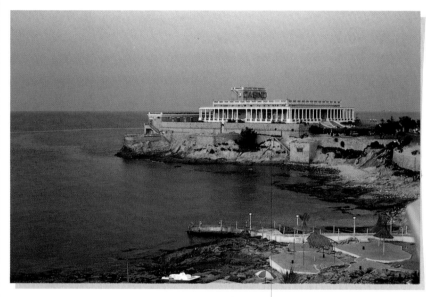

1. EARLY MORNING

Take a shot in the early morning. The dawn sunlight behind and to the left of the camera, gives low frontal lighting to this building.

ROCKS •

The pink early light warms up colors generally, most obviously in these rocks facing the dawn.

2. NOON

With the sun directly overhead, shadows are cast downward and directly behind objects. Detail is plentiful, but the lighting is flat.

3. AFTERNOON

In the afternoon, the lighting angle is lower, and elements seem more three dimensional as a result. This is noticeable above.

MOVABLE SUBJECTS

ROTATING THE SUBJECT
Movable subjects can be rotated, together with the camera, so that at any time of day they are lit by sunlight from any direction you choose. Bear in mind that background details will change, as shown below.

ALTERING CAMERA ANGLE
To prevent the subject being submerged by the background, alter the angle of the camera. A low angle, looking up at the

subject, could show it framed against an uncluttered skyline. A high angle, looking down, could show it against a backdrop of grass or in some other unobtrusive setting.

NOTE
If the sky dominates the picture, be careful not to produce a silhouette of your subject. The camera's **AE** system may read the high background light levels and close the lens **aperture** down or shorten **shutter speeds**.

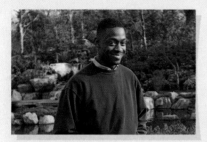
Frontal sidelighting

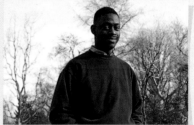
Low camera angle

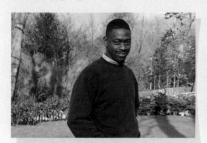
Frontal lighting

Sidelight from left

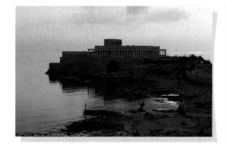

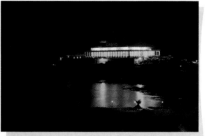

4. DUSK
At dusk, try shooting almost directly towards the sun, setting the **exposure** for the sky; now the promontory is a simple, dark shape.

5. AFTER DARK
Natural details are masked by artificial lighting at night. With light reflecting off the water too, the building looks more boatlike.

SKILL
6

Coping with Contrast

Learning how to reduce the ratio between shadow and highlight and produce a more natural result

Using Fill-in

Our eyes see more detail in the **highlights** and shadows of **contrasting** scenes than film is able to record at any one **exposure**. This may mean either lightening the shadows or dimming the highlights. Place a large reflective surface facing the shadowed part of the subject. This will "bounce" light from the lit side into the shadows, lightening them. The **reflector** could be a sheet of white card, or you could try moving the subject close to a white wall. If the subject is large or immovable, look for a viewpoint where nearby objects reflect light into its shadow areas.

1. NO FILL-IN
If you position your subject beside a bright window, the contrast may look acceptable, but detail in both lit and unlit areas will not record. Altering **exposure** will either reduce shadows but "burn out" the lighter parts, or improve lit detail but darken shadows.

2. REFLECTOR
Try lessening **contrast** by hanging a large sheet of white card on the subject's shadow side (far right). **Exposure** was the same for both shots, but the difference is noticeable.

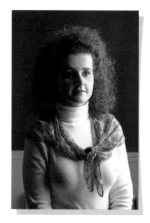

1 No fill-in

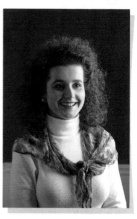

2 Reflector 1m (3ft) from face

3. CLOSER IN
Move the reflector closer to the subject and position it nearer the camera so that it has a more frontal effect Here, this is most noticeable in the previously still shaded eye (**2**). Try the reflector in different positions to fully understand its effect.

4. TINTED FILL-IN
Unless you want a special effect, avoid using colored surfaces. Here, a yellowy-orange **reflector** tints subject shadows, seen most clearly on the white sweater.

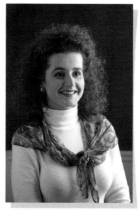

3 Closer, more frontal reflector

4 Tinted fill-in

5. NATURAL FILL-IN
Below: When only part of the picture needs **fill-in**, try reflecting light off something that appears naturally in the shot. In this picture, the white pages of the book reflect back soft illumination into shadowy parts of the woman's face, lightening the shadows sufficiently to reduce harsh **contrast**.

• **BACKLIGHTING**
Direct light from the window to the right and rear of the figure **highlights** her hair and shoulder, but if used alone would underlight her face.

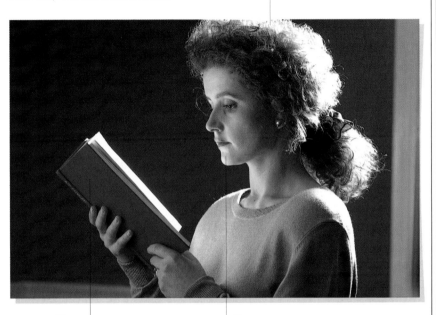

BOOK •
Some light is returned from a cloth-covered table, lighting the book cover and hands.

• **FACE**
Light from behind the figure reflects off the white pages of the book to illuminate her profile in a totally natural way.

JUDGING LIGHTING CONTRAST

CLOSE YOUR EYES
You do not need to be obsessive about recording detail all the time – exaggerated shadow density may damage the picture, but sometimes it adds impact to the shot. It is useful, however, to be able to judge lighting **contrast** by eye in order to forecast how the subject will appear. As a rough guide, half close your eyes and carefully observe the scene through your eyelashes. Shadows appear darker and lose detail where **fill-in** light will be needed.

TECHNICAL APPROACH
A technical approach to judging contrast involves coming in close with your camera (or using its spot meter if your camera has that option) to take separate readings of the most important **highlight** and shadow areas of the subject.

For example, part of a face nearest the light source might read $\frac{1}{125}$ at f11, whereas the shadow side might read $\frac{1}{125}$ at f5.6. A difference of this magnitude (two **f-stops**) should be within the range of most films, so "correct" **exposure** could be set midway at, say, $\frac{1}{125}$ at f8. Differences greater than two f-stops (or two **shutter-speed** settings), however, should alert you to the need to reduce contrast. If this is not possible, expose mostly for the highlights or shadows, according to their importance.

ADVANCED LIGHTING

*Learning advanced techniques with light to produce
unusual and interesting results*

PAINTING WITH LIGHT

Moving lights and long **exposure** times can produce fascinating results (see also pp.68-69). You can "draw", for example, with a continuous light source such as a hand torch. Another technique involves firing flash a number of times to reduce **contrast** in a large interior. For these skills, a compact camera (with a **B setting**) has an advantage over an **SLR**, since you can observe the subject while the shutter is open (see p.10). With an SLR, the viewfinder goes blank while the actual exposure is made.

1. LIGHT LINES

Cover a flashlight with a colored **filter,** then switch the room light off and lock the camera shutter open on **B**. Switch on the flashlight and, aiming it back at the camera, "draw" patterns with the beam. For the effect here, the room light was switched on for 1 second to finish off. You will need to use a tripod to steady the camera here.

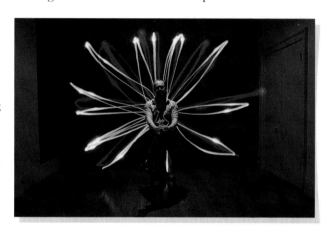

TRAFFIC LIGHT-TRAILS

The patterns formed by moving streams of traffic after dark can make excellent pictorial subjects. Shoot during the evening rush hour, preferably at a busy road junction or flyover. Also, try shooting from a viewpoint that is about knee-high, with a camera and **wide-angle lens** set up on a traffic island in the middle of a main road.

tinting white traffic trails with rainbow hues. Open the lens aperture by about 2 **f-stops** (to f5.6) to compensate for the light lost through the filters.

SETTINGS

Exposure time should allow any one car to travel right across the picture area. As a guide (using 100 **ISO** film), try 20 seconds. An **aperture** of f11 should give you enough **depth of field**.

FILTERS

For variety, add colors by placing **filters** over the lens for all or part of the **exposure** time. Tape together a strip of gelatin filters, and move them up and down throughout the exposure, thus

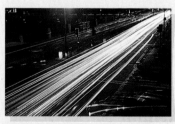

NO FILTERS
This road was shot from a window. **Exposure** was 20 seconds at f11.

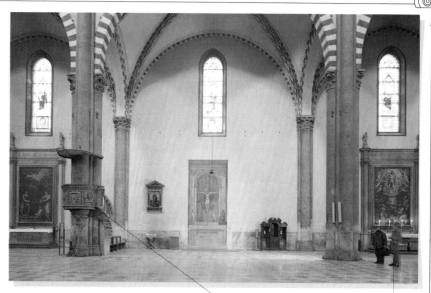

2. MOVING THE LIGHT

Recording all the details in a large, dimly lit interior is a problem with a single flashgun, but try this technique with a non-built-in unit. Mount the camera on a tripod and lock the shutter open on its **B setting**. Then fire the flash manually in the parts of the scene you want to record. It will help if an assistant covers the lens (without jarring the camera) while you move between positions. (For further details, see Skill 7, "Using Flash", pp.50-51, and Skill 10, "Interiors", pp.64-65).

• PULPIT
A diffused flash unit was fired twice from separate positions into this area. The light from the flash has not killed the **existing light**.

FIGURES •
The figures here were posed and had to stand completely still throughout the entire 10-second **exposure**.

TRAFFIC LIGHT-TRAILS

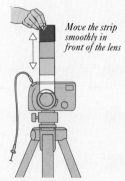

Move the strip smoothly in front of the lens

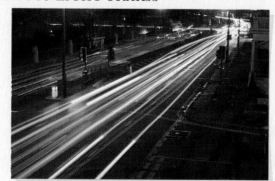

FILTER STRIP
Tape the **filters** together to hold in front of the lens.

WITH FILTERS
In this version, **filters** were moved up and down in front of the lens. **Exposure** was increased to 20 seconds at f5.6.

USING FLASH

Definition: *Deciding if flash is needed, and how to use it*

FLASH IS A CONVENIENT light source, easy to carry around and use anywhere. The burst of light it produces is also brief enough to avoid camera shake and to freeze most subject movement.

OBJECTIVE: To understand on- and off-camera flash. *Rating* ••••

FLASH UNITS

With most **SLR**s, the flash fits into the accessory shoe. Compacts, and a few SLRs, however, have built-in flash units. With these, switch on the flash when it is required, or the **exposure** system switches to flash automatically if light levels are low.

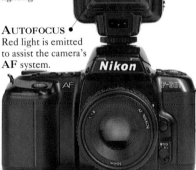

FLASH HEAD •
This light-emitting tube both tilts and swivels to give varied types of lighting.

AUTOFOCUS •
Red light is emitted to assist the camera's **AF** system.

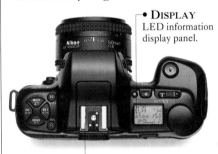

• DISPLAY
LED information display panel.

SHOE •
Electrical contacts fire the flash when the shutter is open.

BUILT-IN •
An integral flash, placed well away from the lens.

ACCESSORY FLASH
Above: Add-on units are more powerful than built-in types, and models with a pivoting head let you bounce light off the ceiling. The shoe on top of the camera has electrical contacts that connect the flash to the shutter.

BUILT-IN FLASH
Left: The flash on a compact is positioned at the farthest point from the lens to minimize the problem of "**red eye**" (opposite). Flash duration is often linked to the autofocus, so that flash output is briefer with close subjects.

COMMON ERRORS

Using on-camera flash is a bit like shooting with the sun directly behind you. With flash, however, near objects receive more light than far ones. To test this light "fall-off", first shoot from a viewpoint with subjects at different distances from the flash. Next, find a new position where the same subjects are more equidistant from the flash. Another problem, associated mostly with built-in flash on both compacts and **SLR**s, is known as **"red eye"**.

UNDER LIT •
Flash power falls off rapidly, and people this far from the camera appear very **underexposed**.

OVER LIT •
The foreground is too close. The camera set the **aperture** and flash duration for the middle area.

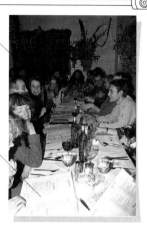

Flash fall-off evident

If subjects are more equidistant, lighting is more even

1. FLASH FALL-OFF

The effect of flash fall-off is largely governed by camera viewpoint. In the smaller picture (above), the subjects are at too many different distances from the camera's built-in flash for it to to cope sufficiently. In the improved version (left), the viewpoint is less "end-on" therefore the subjects are positioned, more or less, equidistant from the flash. Lighting is not only more even, but the space in the middle of the picture has also been avoided.

2. "RED EYE"

A major problem with built-in flash is **"red eye"**. People looking directly towards the camera appear with the (red) retina at the back of the eye reflecting light back at the camera. Many compacts have been badly designed in this respect – something to bear in mind when choosing a camera (see pp.14-15). Some models have a pre-flash that narrows the iris, and thus shades the retina, before the main flash fires. If you have an accessory flashgun, hold it farther away from the lens or, better, bounce light off the ceiling (see p.52).

UNNATURAL •
This unnatural color occurs when flash lights the retina.

NATURAL •
Color is natural because off-camera flash was used.

SKILL

7

INDIRECT & ANGLED FLASH

For a "natural" effect, which mimics the lighting you might expect from soft daylight, use a flash unit that tilts and reflects light off a neutrally colored ceiling or wall. For a greater range, you could also use a flash connected to the camera by an extension cable. This allows light to reach the subject from a wide range of directions. To become thoroughly familiar with the effects of flash, choose a simple subject and take a number of shots, altering the position of the flash each time (see opposite). This is not possible with compacts with built-in, front-facing flash units.

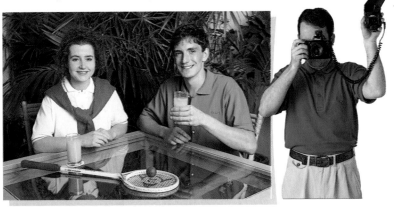

1. BOUNCED FLASH

Bounce light from the ceiling and/or wall above and behind the camera to produce a toplight effect. Avoid colored surfaces or light will show a cast. Only the flash head swivels and tilts – the unit still measures **exposure** from the subject.

POINTS TO WATCH

When directing the light behind you, make sure the flash sensor still points directly at the subject.

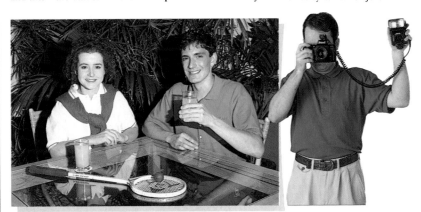

2. DIRECT, ANGLED FLASH

For this lighting technique, hold the flash unit at arm's length and angle it at about 45 degrees to the subjects. The effect is more like that from direct sunlight. Note that shadows are now more distinct than in the first version (**1**).

POINTS TO WATCH

It is easy to hold the flash too high in relation to the subject. Keep the flash level with your head.

B. TOPLIGHT
Flash well above the camera casts a shadow downwards and cannot be seen.

A. OVERCAST LIGHT
Flash pointed at the ceiling and wall on the right gives a natural "overcast daylight".

C. FRONT DIFFUSED
By reversing the flashgun, the lighting becomes frontal and diffused.

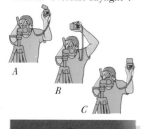

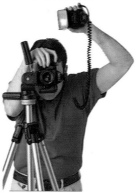

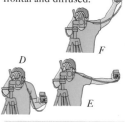

D. UPLIGHTING
Flash fired from well below the lens gives a type of theatrical, "footlight" effect, but it is not really flattering.

E. SIDE AND DIRECT
Flash from the left side allows some light to reflect back from a side wall.

F. MIXED LIGHT
This is a mix of direct light from 45 degrees, with the flash angled up slightly to return light from the ceiling.

ADVANCED FLASH

Once you are confident that you can control flash when used as the dominant light, try combining flash with other light sources, as well as using it for special effects. First, use low-power flash to reduce **contrast** (see pp.46-47). Results may then be more the way you saw the subject. Second, see what happens when you fire one or more flashes while the shutter is open on a long **exposure.** Try this for strange, sometimes bizarre pictures. Results are often unpredictable, however.

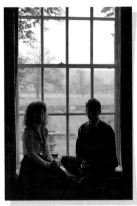

a **Exposure** *measured for outside*

b **Exposure** *measured for room*

1.& 2. FAULTY FILL-IN
For interior shots taken into the light, try to set **exposure** for outdoors with no flash (*a*). This **underexposes** the room, then set flash for the room only (*b*), which **overexposes** the view through the window.

3. NATURAL EFFECT
For this effect, ⅟₁₂₅ at f8 was measured for the view, and a diffused flash set for f8 was used at arm's length to the left of the subjects. Now **exposure** for both indoors and out is more in balance.

• **INDOORS**
The foreground is lit exclusively by flash.

• **OUTDOORS**
The view through the window is lit exclusively by daylight.

4. SPECIAL EFFECTS

To create this type of special effect, which is a mixture of subject blur and "frozen" detail, you need to use the brief burst of light from a flashgun combined with a slow **shutter speed** – here ¼ instead of the usual ¹⁄₁₂₅ flash synchronization setting. In this example, the lens **aperture** was f16, which was correct for both the flash unit and the darkening evening sky behind the athlete.

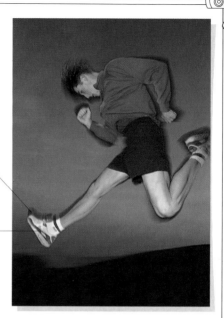

SHADOW •
A shadow is formed on the sky because the figure continues to move while the shutter is open (after the flash had fired).

FOREGROUND •
The foreground elements record with most frozen detail because they are closest to on-camera flash.

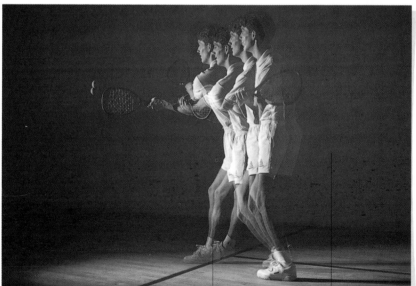

5. MULTI-IMAGE FLASH

Mount the camera on a tripod in a darkened area. Next, lock the camera shutter open on its **B setting** and fire the flash a number of times. Here, the subject was a squash player and the flash was fired from the left towards him four times in rapid succession. The shutter was then manually reclosed.

BLACK OUT •
The background must be blacked out or detail in the room will start to record through the figure.

• MULTI-IMAGE
Each flash of light has frozen the figure as he moved between firings.

8 PEOPLE SHOTS

Definition: *The techniques of basic portrait photography*

EACH DIFFERENT TYPE of subject challenges you with problems and opportunities. When photographing people, you must be conscious of pose and expression, as well as considering lighting and background. These factors apply both to a formal portrait and a candid shot, irrespective of the type of camera you use.

OBJECTIVE: To devise a basic checklist for taking portraits. *Rating* •••

INFORMAL HEAD SHOT

When taking outdoor shots, consider the lighting and background as well as subject expression. Avoid light that makes the subject squint; and if the background is distracting, use a wide **aperture** to render it unsharp.

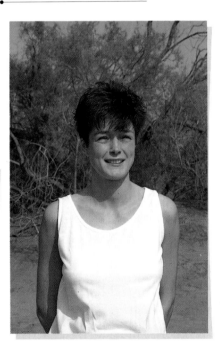

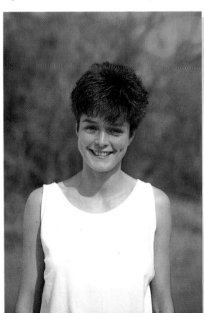

1. DIRECT SUNLIGHT
Above: This photograph shows the subject looking directly at the sun. This has caused her to squint uncomfortably. Here, the background is also unattractive and assertive.

2. HAZY SUNLIGHT
Left: You will much improve this type of shot by waiting for hazy sunlight and setting a wide **aperture** to soften the background.

FACIAL SHAPE

In portraits with the head filling the frame, small changes in viewpoint can make large differences to the subject's appearance. You can alter shape of the face, for example, by emphasizing some features and suppressing others. **Focal length** also affects subject appearance – a **longer lens** gives you a large image from farther away, and the flattened perspective that is produced is least likely to distort features (see p.33).

1. SQUARE-ON
Right: First, position the camera square-on to the subject. As shown here, this viewpoint tends to produce a more rounded facial appearance, and is particularly useful for filling out a very thin face.

2. LOW VIEWPOINT
Above: Next, take the same subject from below. This view draws attention to the nostrils and the face looks less natural with the camera below eye level. Lighting here was the same as before.

3. THREE-QUARTER
Right: Try using a three-quarter view. This has the effect of narrowing the face. Here, although lighting is still the same as in the other two portaits, the subject's appearance is very different.

SKILL

8

CANDID & GROUP SHOTS

Candid shots call for a quick eye and sharp reflexes. Look out for situations in which people are engrossed in an activity and are not taking any notice of the camera. Even specially posed groups can appear informal by the way you use the environment.

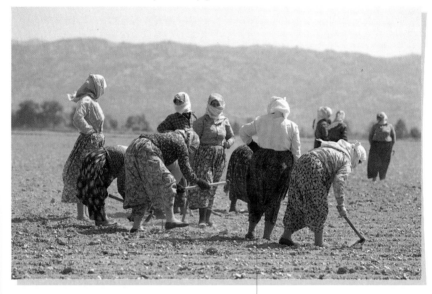

1. UNPOSED GROUPS
Pick carefully your moment to shoot unposed groups. Here, the photographer has made these individuals into a unified composition. Just moments either side of the shot, the figures had a disjointed pictorial relationship.

• COMMON ACTIVITY
Harmony of color throughout the frame and the repetition of their activities draw these people together to form a powerful composition.

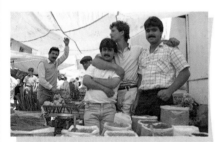

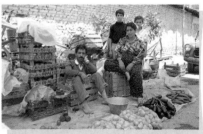

2. SPONTANEOUS POSING
Sometimes, what starts out as a posed group becomes more impromptu. By picking this moment, when the figure at the rear of the group joins in, the photographer has added sparkle to a potentially static image.

3. NATURAL POSING
You can try a little "tweaking" if necessary. The parents were in these poses and the photographer simply asked their children to move into shot. The crates and produce help to fill the frame and add pictorial interest.

4. COMPLEX GROUP

Have a go at arranging a large group in a complex environment. Although the tree in the shot near right, provides an appealing frame, its complicated shape brings only confusion and is simply an unnecessary distraction.

5. SIMPLE GROUP

Next, attempt to simplify your group. Here, softer lighting and the arrangement of the children within the converging lines of the background gives the shot more symmetry and avoids over-elaborate posing.

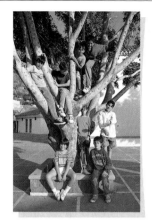

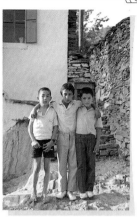

Distracting environment

Beneficial environment

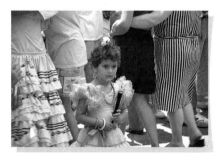

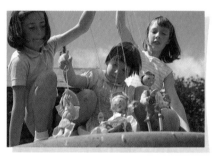

6. EYE LINE

Take a photograph that emphasizes size and concentrates on subject detail. This child's mood and sense of isolation has been caught because the camera was held at her eye level. She seems dwarfed by a sea of adults all moving in the opposite direction.

7. ADDING DYNAMISM

Now, go even lower with the camera to impart more dynamism. For this informal picture, the photographer rested a compact camera, tilted upwards, on the road surface, and snapped the photograph without monitoring the group through the viewfinder.

SEQUENCES

One approach to photographing people in their environment is to take a sequence of pictures. In this set of three, framing was used to emphasize movement through the image. In shot 1, foreground dominates, implying the distance still to be traveled; shot 2 has the subject more centrally framed; while in shot 3, the background dominates, suggesting the distance the figure has already traveled (see p.27).

1 Foreground domination

2 Central framing

3 Background domination

9 LANDSCAPES

Definition: *Using part of a scene to express the whole*

BROAD, GENERALIZED SUBJECTS, such as views of scenery or of cities, are often disappointing in print form. The wide expanse of scenery stretching before you, or the towering city buildings looming over you, as they appeared at the time of shooting, look somehow insubstantial and diminished. A large print may, of course, help to restore at least some of the scene's original impact, as will a projected transparency. Often, however, you will see a distinct improvement in your photographs, no matter what their size, if you first select a single dominant feature from that general scene. With this as your subject, find a viewpoint that shows sufficient of the surroundings to give that feature a proper context.

OBJECTIVE: To make choices of viewpoint and lighting. *Rating* ••••

CHOOSING FEATURES

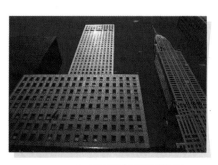

Picture impact has a lot to do with simplifying its elements. Examined here are the effects of simplification by camera viewpoint, by using a lens to alter the angle of view, by **exposing** to emphasize or suppress features, and by choosing the time of day to shoot.

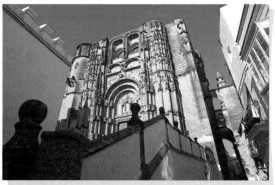

1. CONVERGENCE
Above: Use a **wide-angle** and tilt the camera up at, say, a building, and you will see lines steeply converge. The lens includes sufficient of the subject to indicate its size.

2. DUAL QUALITIES
Left: Although converging lines feature here, as they did above, the real feature of the shot is the lighting, which brings out the subject qualities of color and texture.

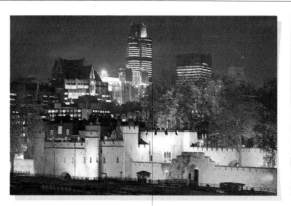

3. TIME OF DAY
If you choose dusk to shoot a picture, you can use the low light levels to hide many features of a cityscape. A tripod will be essential for this, however (see pp.24-25).

• SKYLINE
At dusk, there is still enough light to give a strong and interesting skyline. There is also just enough light to add some details to the shadows.

4. CLOSING IN
Find a close viewpoint, or use a **longer lens**, and aim to limit your view to an isolated detail. Lighting here was bright enough to fill in the shadows and lower **contrast**.

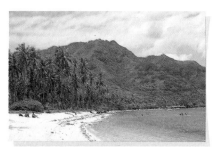

5. OVERALL VIEW
Although this general view is attractive, there is no single picture element you can identify as being the subject of the shot.

6. SELECTIVE VIEW
As a comparison, consider this view of the same scene. Here, a carefully choosen angle has enhanced the "feel" of a tropical isle.

USING REFLECTIONS

PATTERNS
Reflections will introduce interesting abstract effects. Buildings alter their shape when reflected in water, or in the glass walls of the nearby buildings.

EXPOSURE
Measure **exposure** for the reflected detail if that is what you want to emphasize, and choose a small **aperture** if you want both the reflections and the reflective surfaces sharp. Check the effect produced in the viewfinder – a small change in camera viewpoint can greatly alter subject appearance.

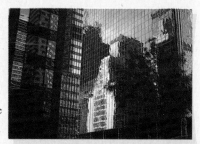

Buildings reflected in buildings

SKILL

9

SCALE & ATMOSPHERE

Try to include a prominent feature in landscape shots. The inclusion of people can impart a sense of scale and provide an obvious focus of attention. When choosing a time for your landscape photography, bear in mind that not all scenes require "good" weather: mist or rain may be characteristic of the location, and a stormy sky can add extra drama.

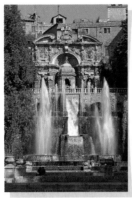

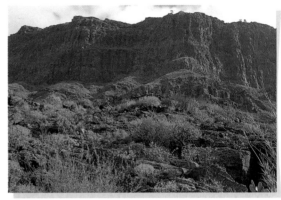

1. CITYSCAPE
If a scene has no obvious center of interest, as here, try to include people in the picture to provide a focus.

2. SCALE IN A LANDSCAPE
Photograph the same scene with and without a figure in shot. The figure here gives scale to a previously unlimited vista and imparts an instant impression of the size of his surroundings. His bright red clothing is a strong color **contrast**, too.

PANORAMAS

Successful panoramas can be taken using a standard lens. This panorama of Mykonos Harbour in Greece was shot with a 50mm lens. A **motordrive** camera made it unnecessary to remove the eye from the viewfinder between shots.

NOTES FOR SUCCESS
• Avoid **wide-angle** lenses for any composite panoramas because of the risk of distortion at the frame edges.
• Take all shots from the same spot, having first decided on which features to show at both the start and finish of the panorama.
• Overlap consecutive images by about 20 per cent, and make sure you keep the camera horizontal.
• For a good match, do not include moving figures or detailed objects in the immediate foreground.

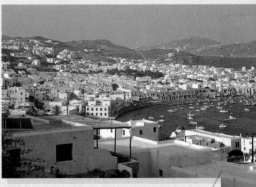

DENSITY •
Differences in density where prints meet are the result of uneven printing – overlapping shots helps to match tones.

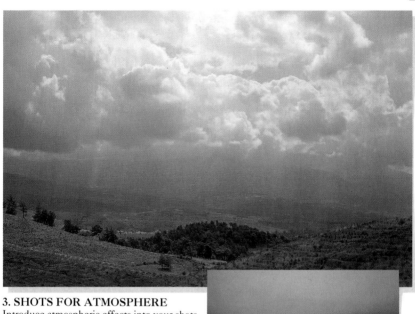

3. SHOTS FOR ATMOSPHERE

Introduce atmospheric effects into your shots to increase interest. Above: Try shooting into the sun to darken tones and colors in the landscape. Avoid **flare** by using a lens hood or shade the lens with your hand. Right: At dusk, capture a hazy, moody sunset. Flare is less of a problem because the sun is weaker and its light more scattered and diffused.

PANORAMAS

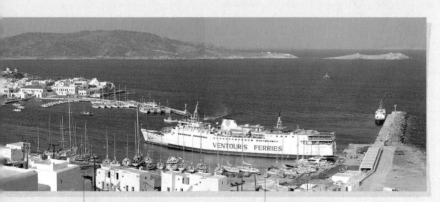

- **FINISHING OFF**
For a neat appearance, mask off any areas of prints standing proud of their neighbors.

- **FOREGROUND**
By keeping the foreground simple, a better match of detail is possible.

SKILL

10 INTERIORS

DAY 2

Definition: *Recording important interior details*

THERE ARE TWO MAIN problems to overcome with interiors. First, is trying to get all the subject detail into the frame from a restricted camera position. The other is lighting dimness, **contrast**, and color.

OBJECTIVE: To record the natural appearance of an interior. *Rating* ••••

CHOICE OF LENS

A 50mm lens outdoors frames a scene similar to your field of vision. Used indoors, however, it seems to give a restricted view. Try moving back to get more in the frame, or change to a **wide-angle lens** or setting, such as 28mm. Even wider-angle lenses are available but these give increasingly "steep" perspective (see p.32). A **long lens** will help fill the frame with distant subject detail.

1. 35MM LENS
On a 35mm setting, take an interior shot. Avoid including windows, to reduce **contrast**. **Depth of field** for this image required f11, and the camera's **AE** set 4 seconds.

REVEALING DETAIL •
Detail barely visible to the eye records during the long **exposure** set by the camera meter.

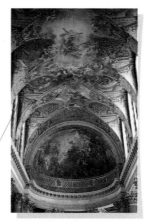

*Dim light and low **contrast***

2. 24-28MM LENS
Right: If you can, next use a 24 or 28mm lens to broaden your view. Notice the effect of a 24mm lens here – shapes towards the picture corners are distorted. This shot had a 3-second **exposure** at f16. To record interior features, detail in the window was sacrificed. (In interiors, on-camera flash will underlight distant detail; a long exposure with existing light is probably better.)

3. 80MM LENS
Far right: Now try moving back and using an 80mm lens to avoid distortion.

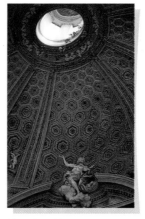

Distortion with a 24mm lens

An 80mm lens lessens distortion

4. FRAMING

Right: Experiment with framing by enclosing your subject within an entrance arch, window, or mirror. This picture was taken into the light entering the room, however, a window behind the camera provided good **fill-in** illumination.

5. FEATURES

Far right: Pick out particular features in a room to capture its character as well as its contents. Here, the fireplace is made into the focal point. A 28mm **wide-angle lens** setting was used for photographs **4** and **5**.

Using a doorway as a "frame"

Choosing a feature to dominate

6. STILL-LIFE SHOTS

Now, use a **longer lens** and attempt to find a still-life arrangement within the room. If it is backlit, as here, take a close-up reading and lock the settings into the camera. Then recompose the shot from farther back. Here, a sheet held behind the camera returned daylight from the windows to light the objects sympathetically.

OUTSIDE DETAIL • Detail seen through the window is two **f-stops overexposed**.

EXPOSURE • **Exposure** was measured from this point.

An informal still-life arrangement

SIMPLIFYING INTERIORS

CLUTTER
Very often, a room or living area furnished for normal life appears to be far too cluttered and complex to make a good photograph (near right). Remove all extraneous subject elements to help impart structure.

CLUTTER FREE
In the next version (far right), the architectural features of the covered courtyard are allowed to dominate. The tables and chairs are suggested by the lone chair being used by the subject. The result is simpler and more direct.

Reality can be too cluttered

Less detail, but a stronger image

11 ACTION SHOTS

DAY 2

Definition: *Interpreting moving subjects in different ways*

IF YOUR CAMERA has a good range of selectable **shutter speeds**, and also allows the use of flash, you have the opportunity to record subject movement in a variety of different ways. At one extreme, the use of flash close up to the subject will "freeze" all appearance of movement. At the other extreme, you can explore how slow shutter speeds will record varying degrees of semi-abstract blur.

OBJECTIVE: To control results when the subject is moving. *Rating* •••••

SPEED AND DIRECTION

Assuming the camera is supported and stationary, the amount of blur from a moving subject depends on two main factors. First, the **shutter speed** – the time the shutter is open; and, second, the speed at which the subject moves on the film during the **exposure**. Image movement depends on the speed of the subject and also its direction and its size in the frame. Try the angles of movement shown here to learn their effect on action.

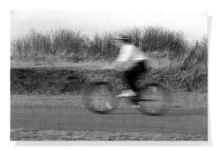

1. RIGHT-ANGLE MOVEMENT
With this subject traveling at right-angles to the camera and a **shutter speed** of ⅕s, the result is considerable blur. Here, some of the bike records with more detail than others.

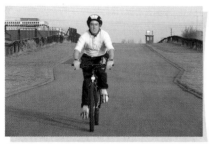

2. HEAD-ON MOVEMENT
Now, with the subject traveling at the same speed as before (**1**), and **shutter speed** still at ⅕s, this photograph was shot from head-on. Image blur is now less, due to the angle.

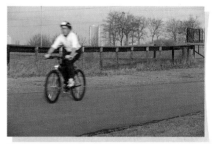

3. ANGLED MOVEMENT
Using the same settings, this photograph was taken at a 45 degree angle. Apparent movement is greater than when the angle was head-on (**2**), but less than in image **1**.

FLASH

Flash is a convenient way to "freeze" subject action, since in dim lighting flash duration effectively becomes the **shutter speed**. Flash duration is usually about $\frac{1}{500}$ or $\frac{1}{1000}$, but when used close to the subject this can shorten to as little as $\frac{1}{10,000}$ or less to avoid **overexposure**.

1. "FROZEN" WATER
For this effect, use a flash close to the subject – here 1.5m (5ft) to the left of the subject. Sidelighting and short flash duration pick out every water droplet.

DROPLETS •
Even the fastest-moving water is frozen. The effect is dramatic, but unlike anything the eye would see.

PEAK OF ACTION

With most action subjects, capturing the key moment is a test of fast reflexes and co-ordination between eye and finger. No matter how fast the **shutter speed**, releasing the shutter early or late will miss the right moment. Even the slight delay caused while an automatic camera searches for true focus can be a hindrance.

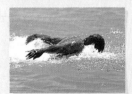

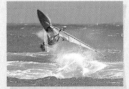

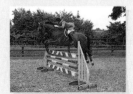

CLOSE ACTION
A pan, even at $\frac{1}{500}$, allows you more time to compose and shoot action pictures.

DISTANT ACTION
A 135mm **telephoto lens** fills the frame at a distance, and $\frac{1}{250}$ records some blur.

TIMING
The impact here has a lot to do with the horse's legs all being off the ground.

ABSTRACT ACTION

Recording the movement of light at night to produce abstract effects

LIGHTS AT NIGHT

A slow **shutter speed** to record blur often gives a heightened sense of action. Or, moving the camera during a long **exposure** can make a static subject into an action shot. Try shooting lights – fairgrounds, store windows, and other luminous objects – at night. Now you can turn excessive **contrast** (see pp.46-47) to your advantage, creating swirling images in an otherwise black frame. Suggesting movement like this is not an exact technique. Therefore, always **bracket** exposures, varying not only the exposure time but also the proportion of this time that the image, or the camera, is stationary or moving during the exposure.

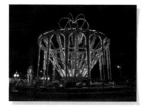

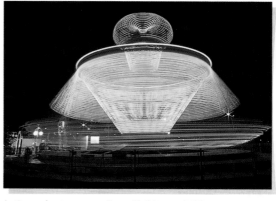

1. STATIC CAMERA

A fairground can produce magical images. Take a shot, as here (above), of a static "ride". This was given 1 second at f4. Then record it moving (right). **Exposure** here was 8 seconds at f11.

*An 8-second **exposure** transforms this fairground ride*

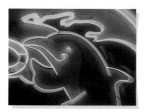

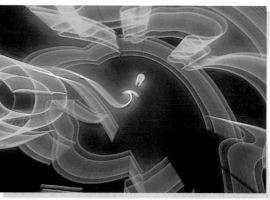

2. ZOOMING THE LENS

Pick a stationary light – here a neon sign was used, and the **exposure** was 3 seconds at f8 (above). Next, try zooming the lens throughout the same exposure. This gives a much livelier interpretation (right).

*Zooming during the **exposure** makes the neon appear almost to throb*

3. COMBINED EFFECT

Now, attempt further image abstraction by shooting through one set of moving lights towards another, carefully aligning them first to create an attractive effect.

4. DOUBLING UP

For really unpredictable results, try moving the camera while shooting a moving subject. This effect was achieved by moving the camera in several arcs during a 12-second **exposure**.

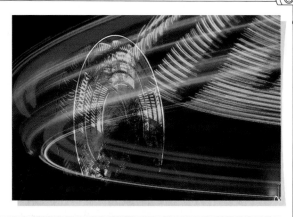

STAGE 1 •
Shapes caused by the rotating outer rim of the big wheel before camera began to move.

STAGE 2 •
"Meteor" streaks, cropped off when the shutter closed while the lights were at these positions.

PICKING A SUBJECT

Many simple subjects create strong patterns if shot with the camera set to a slow **shutter speed**. You could, for example, lay your camera on the floor of a dark room with the lens looking up at a swinging light bulb. By moving different-coloured **filters** across the lens during the **exposure**, you would record multicoloured swings and ellipses. Another subject is a busy road junction at night – the streams of traffic moving in different directions form continuous ribbons of white head lights and red tail lights (see pp.48-49). It is also possible to "paint with light" using a moving torch pointed at the camera in a dark room or outdoors at night. For all these suggestions you will have to make test shots, guessing the exposure needed.

SKILL

DAY 2

12 CLOSE-UPS

Definition: *Shooting small objects and details*

CAMERAS SELDOM FOCUS closer than 30-50cm (12-20in). To work closer in than this with an **SLR**, you have to use an attachment that moves the lens farther away from the camera body. With a compact, the lens is fixed and this is not possible, but some have a "**macro**" focus setting, or accept a close-up lens attachment on the front of the lens. Lighting is another consideration with some subjects.

OBJECTIVE: To use a range of equipment and lighting. *Rating* •••••

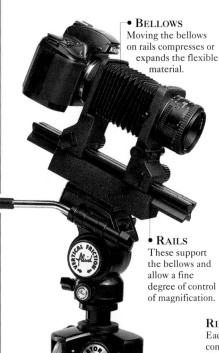

• BELLOWS
Moving the bellows on rails compresses or expands the flexible material.

CLOSE-UP EQUIPMENT

An **SLR** is best for close-ups because its viewfinder shows precise framing. The simplest attachments are rings, which fit singly, or in combination, between the lens and body to give fixed magnifications. A bellows is an accordion. Stretching or compressing the accordion alters magnification.

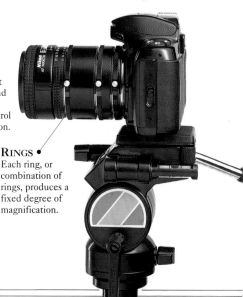

• RAILS
These support the bellows and allow a fine degree of control of magnification.

RINGS •
Each ring, or combination of rings, produces a fixed degree of magnification.

RECORDING DETAIL

Distracting backgrounds can mar close-ups; lighting is also tricky, since the camera blocks any available light. To minimize both problems, use a flash directed at the subject and set **exposure** to darken the background. **Depth of field** is greatly reduced in close-ups, so work with **apertures** of at least f16 or f22, and set focus midway through the subject.

TRICKY LIGHTING
Unsharp **highlights** in the background spoil this shot.

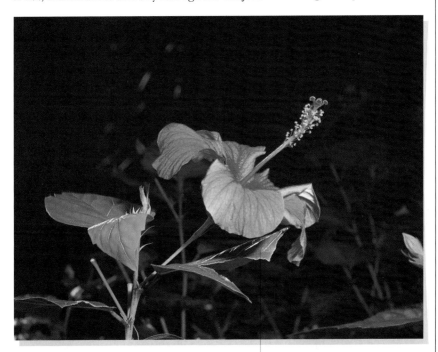

USING FLASH
Above: Try taking close-up shots using flash to suppress the background. Direct the flash solely at the subject. This flower was taken using flash light channeled through a cone made of cardboard. This subdued the less interesting background.

SUBJECT •
Light falls only on the subject; the background is darkened.

DEPTH OF FIELD
Right: Choosing an object with plenty of intricate detail, experiment with **depth of field**. Always focus midway through the subject as depth of field extends behind and in front of the point of focus. Small **apertures** of between f16 and f22 are needed to ensure everything is in focus.

UNSHARP •
Both the hat and lower half of the body are unsharp at a setting of f5.6. F22 is a better choice.

Insufficient sharpness at f5.6

SKILL

12 CORRECT LIGHTING

Once you are confident using close-up equipment, and have overcome the problem of shallow **depth of field** at close focusing distances (see pp.70-71), you need to turn your attention to subject lighting. Lighting plays an important role in revealing detail. However, the nature of the object itself may create problems. For example, polished metal can throw back detail-obscuring reflections unless it is carefully lit.

1. REFLECTIVE SURFACES
Lighting for a reflective surface, such as this predominantly silver earring, is often best if heavily diffused. Try diffusing daylight by placing an arched sheet of tracing paper over the object, with a hole cut in it for the lens.

2. MINUTE DETAIL
Use extension rings (see p.70) for images this size. Some oblique lighting is needed to pick out details such as a hallmark. Here, this was achieved by lifting an edge of tracing paper above the item to let in some direct daylight.

3. FLAT SUBJECTS
Position the camera square-on to the subject when taking close-ups of two-dimensional subjects such as stamps, and make sure that lighting is even across their surface for accurate color results. For stamps, use diffused daylight or try positioning one lamp either side of them so that the light falls at 30 degrees to their surface. Check in the viewfinder that the subject edges are parallel to the sides of the frame to avoid distortion.

CLOSE-UP COLOR

COLOR ACCURACY
For slides shot under **incandescent lighting**, there is a special type of emulsion (see pp.18-19). Daylight-balanced film is for use in daylight and with flashguns. Under incandescent light, it shows an orange cast unless you fit an 80a **filter** on the lens. With color negatives, colors can be adjusted in printing, so film type is less critical, although an 80a filter is best.

COLOR GUIDE
For some subjects, such as stamps and silver, it is vital to reproduce the correct color in printing. To assist the processing laboratory, include at the edge of the frame something that is of known color – perhaps a film carton. This will help the processor balance the color of the print overall, and the item can then be trimmed off the print later.

TRICKY ITEMS

*Coping with objects that present
particular photographic problems*

GLASS OBJECTS

Glass can be tricky to light, since
there is usually no surface texture and
the lighting needs to concentrate on
accentuating other attributes – the
item's transparency, shape, form, and
smoothness. Stores practically always
light their glass displays from the rear,
and sometimes even from below, if
shelving is also glass. Direct, frontal
lighting simply causes glare spots.

1. SMOOTH GLASS
Set an object, such as a bottle, on a window-
sill, and cover the window behind with
tracing paper. Here, the dark edges are due
to reflection from the window rebates.

2. FACETED GLASS
Light deeply-cut glass from one side, so that
some of the indentations fill with shadow,
producing some **contrast**. Try to exploit the
pictorial use of any reflections. These have
been used to advantage in this image.

• SLIGHT FILL-IN
A pale-grey card **reflector** was
used out of shot to return some
light to fill-in this shadowed
side of the glass bowl.

13 AFTER DARK

Definition: *Picture-making possibilities at night*

MANY MODERN SLRs and some compacts contain light-reading electronics sensitive enough to set **exposures** of several. You can also buy fast color or black and white film (see pp.18-19). When used together, you have the option of shooting pictures after dark without introducing artificial flashlighting to the scene.

OBJECTIVE: To avoid using flashlighting at night. *Rating* ••••

PEOPLE AT NIGHT

The streets abound with unusual light sources after dark, including store windows and illuminated signs. Light intensity will be low, however, so shoot at widest **aperture** and use 400-1600 **ISO** film. **Contrast** (see pp.46-47) is harsher than during the day, giving shadows dense enough to obscure features, so work with the main light behind you and the subject frontally lit. Even with fast film, **exposures** arc long, making a camera support necessary (see pp.16-17).

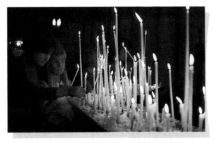

1. CANDLE LIGHT
Try shooting a subject lit only with candles. For this shot in a dark cathedral, **exposure** was ⅟₁₅ at f1.8 on 400 **ISO** film. With so little **depth of field**, focusing is critical. Use a tripod or rest the camera on a solid surface.

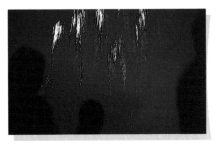

2. SILHOUETTES
Now, try a more graphic image, simplifying figures into silhouettes. The shapes here are shown against a sky that is illuminated by fireworks. **Exposure** was 1 second at f5.6. The camera was supported on a wall.

— NIGHT EXPOSURE —

• Set a small **aperture** for extensive (or a wide aperture for shallow) **depth of field**, depending on the requirements of your particular subject.
• Take one frame at the **shutter speed** determined by the camera, or the speed set by an auto exposure system.
• Next, manually set faster and slower shutter speeds for **bracketed** shots.
• With an automatic camera, use the **exposure** override dial.
• If you want a face to record clearly, take a close-up reading off your own hand, if the lighting is similar to that illuminating the subject.

BUILDINGS AT NIGHT

Floodlit buildings can make interesting subjects (see also p.61). The color of the lighting used varies considerably – some light is tinted, while other light aims to give a "true" color impression. Reflections provide extra interest, too. Pick a viewpoint where the reflections fall towards the camera and fill up otherwise empty areas of the frame.

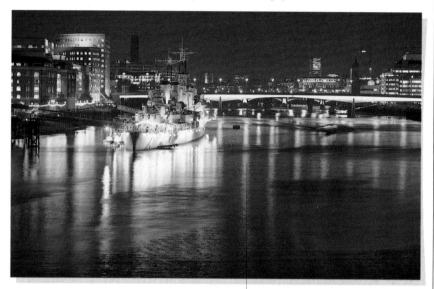

1. EXPOSURE OVERRIDE
Here, important lit areas are relatively small and would be **overexposed** by the **AE** system. The AE recommended 8 seconds at f5.6, but the chosen **exposure** was only 4 seconds at f5.6.

• REFLECTIONS
Water movement has "smoothed out" the reflections seen at the time. For similar reasons, any camera movement will completely destroy subject details.

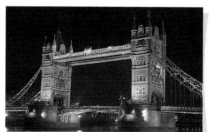

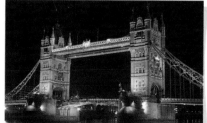

2. NATURAL EFFECT
Generally, film that is daylight-balanced gives results that correspond more closely to the way the scene looked to the eye. Compose the subject carefully so that it stands out against its deep black surroundings.

3. FILTERED RESULT
Now, using a range of **filters** (including split and half filters), create your own color scheme. For this version of London's Tower Bridge, a blue-colored 80a daylight-conversion filter was fitted on the lens.

AFTER THE WEEKEND

Furthering your photographic interests and skills

•

THE TWO MAIN ASPECTS of photography – technique and the ability to "see" a good picture – tend to progress at different rates. At first, technique seems overwhelming, but most of it is repetitive, like operating any other machine. Using the **aperture** to control **depth of field**, for example, or shutter to vary the degree of subject blur, soon becomes second nature. However, sharpening your perception of what constitutes a good picture takes longer, since each subject and possible visual approach presents its own challenge.

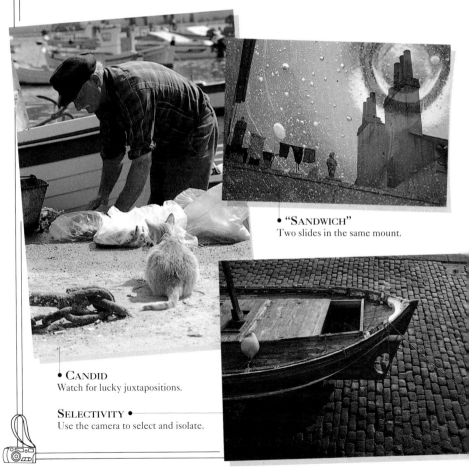

• "SANDWICH"
Two slides in the same mount.

• CANDID
Watch for lucky juxtapositions.

SELECTIVITY •
Use the camera to select and isolate.

Probably the best way to proceed is to set your own photographic themes and projects. These don't have to be of monumentous events – you might choose a theme based on a children's party or animals and their owners. Or you could shoot a series of pictures based on pattern and texture, using simple things you see around you at home, work, or on vacation. Some of the results will be strong pictures in themselves; others you may decide to reshoot from another angle or at another time of day when the light is more sympathetic. Still others may trigger new areas of photographic interest you were not aware of. At some stage you may want to compare your skills and learn others from more experienced photographers, or simply meet people who share your interest. If so, most areas of the country have photographic clubs, which hold regular competitions and talks. Some clubs may even have darkrooms, where you can start to experiment with making your own prints.

• CONTRAST
Look out for interesting or unexpected contrasts in natural forms.

• BACKGROUND
Backgrounds should not compete with the main subject.

BLACK & WHITE

Removing color can add another dimension to your results

•

BLACK AND WHITE PHOTOGRAPHY makes a refreshing change from color for several reasons. First, results are a simplification of reality – pictures are created from tone values rather than the familiar, and sometimes exaggerated, patterns of colors. Second, there is no need to worry about an unwanted dominant color in the composition "stealing" undue attention, and mixed lighting sources, are no longer a problem either. However, you will have to learn to anticipate how the scene in front of the camera will translate into shades of grey. This can be difficult, especially when some subject colors, such as reds and greens, reproduce as nearly identical greys.

FILM EXPOSURE

Due to a decline in popularity, relatively few films are made for black and white, but there is still a good choice in the 32 to 400 **ISO** range. The secret of a good print lies in a correctly **exposed** negative. An **underexposed** negative lacks shadow detail and looks "thin". **Overexposure** gives a "dense" negative, with missing **highlight** detail. Neither result gives a rich, full-tone print.

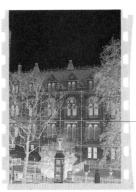

Correctly exposed

CORRECT
The wide range of tones and subject detail in this negative indicate that it should yield a good print.

• SUBJECT SHADOWS
Look for detail in shadow areas, such as this dark foliage.

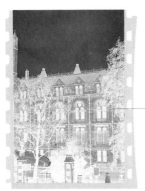

Underexposed

OVER AND UNDER
Left: This negative received a quarter of correct **exposure**. All the dark parts are thin. Right: In this **overexposed** negative, detail has become dense and "choked up".

• EMPTY SHADOWS
Compare the lack of detail with the correctly exposed negative above.

BRICKWORK •
Excessive density fills in fine detail, and tones merge.

Overexposed

GRAIN

Films of 400 **ISO** or less are regarded as fine **grain**, capable of enlargement up to 20 x 25cm (8 x 10in) without any intrusive grain. Films of 1000 ISO or more, especially if given extra development, do begin to show obvious grain. An enlargement of all or part of such a negative can give an interesting effect.

SLOW FILM
Right: This fascia was recorded on 125 **ISO** film. Any **grain** would have destroyed the sense of smooth, metallic forms, and coarsened the range of tones.

• CURVED DETAIL
The range of greys on these curved parts would break down into two or three crude tones on **grainy**, fast film.

FAST FILM
Left: This picture was **exposed** on 3200 **ISO** film (using a **neutral density** filter). It was enlarged from a part of the negative only. As you can see, fine detail has been destroyed and the image looks as if it has been etched.

• GRITTINESS
Notice how **grain** shows up most in what were originally the mid-grey tone areas of the subject. Grain has been exaggerated on purpose in this print, but it needed a high-quality enlarger lens in order to retain the sharp "grittiness" of the negative.

FILTERS FOR BLACK & WHITE

*It is well worth buying some colored **filters** if you intend to experiment with black and white film*

UNDERSTANDING FILTERS

In black and white, a **filter** makes everything matching its own color look lighter on the print, while other colors may appear darker. This makes colors appear to have different tone values than would otherwise be apparent. Hold the filter to your eye to see the effect it will have – colors will lighten and darken in relation to white or grey areas. Colored filters reduce the amount of light reaching the film. **SLR** cameras, which have TTL (through-the-lens) **exposure**, automatically compensate for this; with a compact you may have to use an oversized filter that covers the lens and the separate **AE** sensor (see p.11). The filter mount is engraved with the exposure increase needed. Adjust lens **aperture** or **shutter speed** manually on non-automatic cameras.

Original colored subject

Final print (no filter)

NO FILTER
When colors (left) are shot on black and white with no **filter**, they appear as shown above. Tones are similar to how "dark" or "light" the eye sees the colors.

Colored subject seen through a red filter

Final print (shot with a red filter)

WITH FILTER
When viewed through a red **filter** (left), the red wool appears relatively paler, and green and blue darker, than before. Tonal changes are borne out in the print above.

DRAMATIZING A SKY

A common use of **filters** is to dramatize the appearance of skies. Blue records as a pale tone (see blue wool, opposite), and so easily merges with white clouds. By using a red filter to shoot the picture above, the clouds stand out starkly against the sky. A yellow or an orange filter would have a milder effect.

• STONEWORK
Colored **filters** affect only colored parts of a scene. This stonework is basically grey and its tones are unchanged.

FOLIAGE •
The use of a red **filter** has darkened the green grass.

USING FILTERS

For black and white landscape pictures, the most generally useful colored **filters** tend to be deep yellow, orange, red, and green. You can see how they affect some subjects from the table below. Some filters made specifically for color photography have a double function in black and white photography. A graduated grey or half-color filter, for example, will help prevent you inadvertently **overexposing** sky detail when shooting a scene that contains large areas of dark foreground vegetation.

FILTER	EFFECT (AS SEEN ON PRINT) ON:				
	Deep blue sky	Pale blue sky	White clouds	Green vegetation	Red paint
Deep yellow	Slightly darker	Little change	No change	Paler	Paler
Orange	Darker	Slightly darker	No change	Darker	Much paler
Deep red	Very dark	Darker	No change	Much darker	Very pale
Deep green	Darker	Darker	No change	Much paler	Very dark
Blue	Very pale	Very pale	No change	Paler	Very dark

SPECIAL EFFECTS

Lens attachments can help you to create a wide range of unusual imagery

THERE ARE DOZENS of special effects attachments to help you transform your prints. These, however, should be used sparingly, and only on scenes that respond positively to the type of effect. You can also devise your own image-distortion effects by using materials found commonly around the home – shooting through fluted glass, for example. The angle to which you rotate the attachment on the lens often has a dramatic influence on results. It is, therefore, easier to work with an **SLR**, since you can see the image changes on the focusing screen before making the **exposure**. With a compact, preview the effect by holding the attachment up to your eye. Then, without changing its orientation, carefully transfer it to the camera.

STARBURSTS

A starburst **filter** is made of treated plastic. It is best used on subjects after dark that contain intense, but well separated, **highlights**, which can "spread" into dark areas of the scene. (All starbursts reduce definition slightly.) In this shot of Hong Kong, the filter has given a short spread of light, and every lighted window has become a delicate cross. **Exposure** was 12 seconds at f5.6.

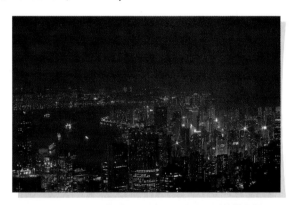

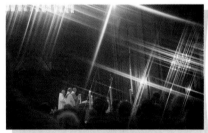

DEGREES OF EFFECT

A stronger starburst was used for this interior shot of Notre Dame Cathedral. Rotating the filter attachment turns all the "spokes" like cartwheels, so it is important to decide, and preview, the best orientation before shooting.

COLORBURST

A colorburst attachment adds prismatic colors. The subject here was a tiny part of the sun peeping over a roof. Always take care not to damage your eyes when viewing the sun, especially through a **long lens**.

DUAL-COLORS

A half **filter** has a band of color across half of its surface. Two half filters produce a dual-color effect, such as the half-red, half-blue type used for this photograph. The red and blue color bands match in strength, so their effect on **exposure** is even across the picture. A filter like this suits an image containing a straight-line division, such as the horizon, across the middle.

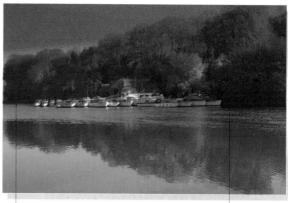

COLOR JUNCTION •
The division between the two colors grows more abrupt as you **stop down** the lens.

FILTER ORIENTATION •
Orient the **filter** so that the color division is hidden by a feature in the shot – here the river.

IMPROVISED EFFECT
This effect was achieved by photographing the children through the patterned glass of a door. Choose your point of focus and **depth of field** carefully in order to achieve the right "cut-out" shapes for the image.

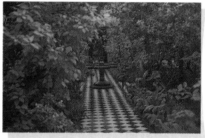

WARM TINTS
Here, the camera photographed through a yellow panel of tinted conservatory glass. The poor-quality glass has diffused the detail as well as generally "warming" subject colors, giving a pleasing, nostalgic effect.

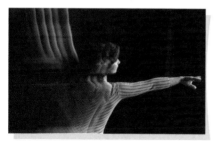

REPEATING IMAGE
The attachment that produced this image has parallel vertical grooves down one half of its surface. These grooves create a multi-repeat pattern of the half of the image they cover. A simple subject tends to work best.

PRISM ATTACHMENT
The middle of the attachment used for this shot is flat, surrounded by four faceted sections that repeat the center image. This effect works best with an isolated subject shape against a plain background.

COMBINING IMAGES

Merging images on the same frame of film can create bizarre results

•

IT IS POSSIBLE to merge images into a single result before, during, or after making the final camera **exposure**. The main challenge is to plan the picture components. They should not compete with each other, but instead form a unity that is stronger and more interesting than the single components. Slide film gives you slightly more opportunities to experiment with these techniques. With slides or negatives, however, no special camera equipment is needed.

USING SLIDES

Using a slide projector, you can "throw" an image on to any white object or surface and photograph the result, or just project two images at once.

PROJECTOR EFFECTS
A slide of leaves was projected on to this bottle in a normally lit room.

STAGE 1
For this first stage of the procedure, a piece of marble was photographed and **overexposed** by about one f-stop to give a pale result.

STAGE 2
This slide of pink lilies against a white backdrop is, also, **overexposed** and pale. forming the second part of the "sandwich".

STAGE 3
Sandwiched between glass in a slide mount, this two-image combination can be projected normally or made into a color print.

CAMERA DOUBLE EXPOSURE

To combine images in the camera, you have to make two **exposures** on the same frame of film. Some cameras offer this facility – by pressing a button when you wind on, the shutter is reset but the film remains stationary. However, any camera with a **B setting** can be used, provided the camera is supported on a tripod. Cover the lens between exposures with a lens cap or black card to stop unwanted light entering the camera.

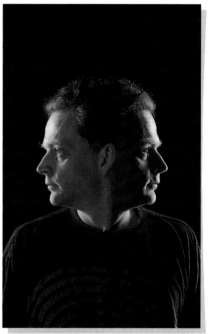

THE BASIC SET-UP
A black background is essential. For this trial shot, the shutter was locked open on its **B setting** in a darkened room, and a small, diffused flashgun was fired from the extreme right, shaded to illuminate only the face.

DOUBLE-HEADER
For this double **exposure**, the trial shot (left) was repeated. The lens was covered with card, the subject turned his head, and the flash was fired again, but now from the extreme left. The shutter was then closed.

USING A HALF MASK

A half mask is a metal- or plastic-rimmed "**filter**" that screws on to the lens. Half the filter consists of a piece of black cardboard. It is an easy way to make double exposures in cameras that allow you to reset the shutter without winding on the film.
•Take readings of the first two subjects with the lens uncovered.
•Set the first reading manually.

•Place the mask over the lens and take the first image.
•Set the second exposure reading if this is different.
•Rotate the half mask by 180 degrees so that the black cardboard part of the filter covers the half of the frame that you have already exposed.
•Now, simply take the next shot.

TROUBLESHOOTING

Learning to identify and avoid common, basic errors on prints and slides

ERRORS CAN OCCUR during shooting and printing. If your print is less than perfect, compare it with its negative. If the negative seems to be fault-free, explain the apparent problem to the processors and ask them to make a new print. One of the advantages of shooting on slide film is that there is no printing stage where things can go wrong – perhaps by making a sunset too light and washed out. Bear in mind that pale or clear negatives indicate **underexposure**; underexposure on slides appears as a dark and impenetrable image.

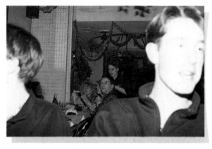

FLASH EXPOSURE
•**Appearance:** Faces washed out.
•**Cause:** The flash tried to expose correctly for the distant figures, but has **overexposed** the pair in the foreground.

FOGGING
•**Appearance:** Flame-like orange bars on the print. The negative has corresponding dark bluish-black patches.
•**Cause:** The camera back was probably opened before the film was rewound into the cassette. The "ghost" pattern of perforations top and bottom suggest that light reached the film obliquely, as if from the opened end of the camera back. Loading or unloading the cassette in bright sunlight can produce similar "fogging". Always check the film is rewound before opening the camera back.

MISSING HEAD
•**Appearance:** Parts of subject cropped off.
•**Cause: Parallax error** due to using a compact too close to a subject. This can also occur with any camera if glasses prevent your eye coming close enough to the eyepiece to see all four corners of the picture.

FLARE
- **Appearance:** One or more patches of light, usually hexagonal in shape.
- **Cause:** Shooting towards the sunlight and not shading the lens.

• LIGHT PATCH
This patch matches the shape of the **aperture**. It becomes smaller and brighter the more the lens is **stopped down**.

COLOR CAST
- **Appearance:** Strong overall color cast.
- **Cause:** Shot by the light filtering through a yellow marquee. Pictures from color negatives can be corrected during printing, but this is beyond the limits possible. In this situation, use a flash, which emits light of the correct color balance.

"RED EYE"
- **Appearance:** Pupils of the eye are bright red when flash lit.
- **Cause:** Due to light from flash reflecting from the back of the eyes. If you cannot change to a faster film and thus avoid using flash, bounce or angle the light from the ceiling or wall.

CONTRAST
•**Appearance:** Shadow areas on print are too dark. These areas on the negative are pale.
•**Cause:** Meter was fooled by the brilliant light entering through the window. Always take a light reading from the main subject alone when it is strongly backlit.

• FIGURE
The camera should have pointed here for the light reading, which could have then been set or locked in to the camera before the image was recomposed and shot.

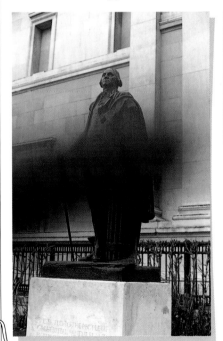

UNDEREXPOSURE
•**Appearance:** A flat-looking result with an overall yellow color cast.
•**Cause:** Extreme **underexposure**. Slow film was used in dim light, and correct **exposure** was beyond the range of the camera's settings. Use faster film if possible.

OBSTRUCTION
•**Appearance:** A dark band extending into the picture. On the negative, it is a clear area.
•**Cause:** An obstruction immediately in front of the lens – probably a finger. Occurs most often with compacts because the viewfinder system may not show anything amiss.

CAMERA SHAKE

•**Appearance:** Multiple images and blur extending over the whole of the picture area.
•**Cause:** Camera movement during **exposure**. This could be due to a combination of slow film, dim lighting, and a slow **shutter speed**. With automatic cameras in **aperture**-priority mode, selecting a small lens aperture of, say, f16 may cause the camera's **AE** system to set a shutter speed of, say, ½ second. Many automatic cameras give a viewfinder signal or an audible "beep" if the shutter speed selected is likely to result in camera shake. With a **telephoto lens** or setting, camera shake is likely to occur at shutter speeds usually considered safe with a shorter **focal length** lens.

MULTI-IMAGES •
A treble image shows clearly here and throughout the picture. This indicates that the camera was in three fairly static but different positions during the **exposure** time. Sometimes results such as this can produce an attractive effect.

"SPOTTING" WHITE MARKS

THE CAUSE
An otherwise good picture can be spoiled by small white marks, often the result of hairs or other tiny debris on the negative masking the enlarger light from that part of the print.

THE CURE
If a reprint is not possible, it is not difficult to "spot" out the defect yourself. You need a size 0 water-color brush, a tube of appropriately colored watercolor or retouching dye, and a magnifying glass. Use the tip of the brush, just slightly damp.

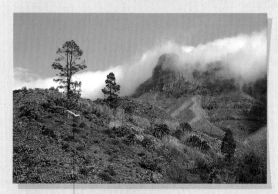

• **HAIR MARK**
"Spot" this type of white hair mark with tiny specks of colored dye.

STORAGE

Make sure your images are protected yet easily accessible

MANY STORAGE SYSTEMS exist to help you look after your film and prints. Slides are usually returned in plastic mounts. These can be filed in projector trays ready for viewing. You can also file them in plastic sheets, where 24 images can be seen at a glance. Negatives are best kept in loose-leaf files. Processed prints can be stored conveniently and safely in display albums.

TRAY •
A straight tray holds up to 50 slides.

SLIDES

You can keep slides in a tray. The circular type (right) fits many projector types. Plastic slide sheets are also convenient.

PROJECTION
Mark the mount as here and load images upside down for correct projection.

BULK STORAGE •
A tray such as this accepts 100 mounted slides.

SLIDE SHEETS •
A clear plastic slide sheet has pockets for 24 slides. Sheets fit into albums or hang in a filing cabinet.

SELECTION •
Individual slides are easy to select from a file sheet. Simply hold it up to any handy light source.

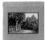

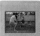

NEGATIVES

Negatives can be very easily lost or damaged. To preserve them long term, carefully cut them up into manageable-sized strips and place each one into a translucent paper sleeve. Don't store these sleeves pressed tightly together, in damp conditions, or near chemical fumes, such as those from ordinary cleaning materials or similar products.

PAPER SLEEVES •
Each sleeve accepts a strip of six negatives. The paper is specially made from material that will not react with the film emulsion.

RING FILE •
Sheets of sleeves go into a file. A date or reference number for each page, along with the film edge numbers, identifies each image.

CONTACTS •
Sheets of small prints can be filed next to their negatives.

PRINTS

Modern print albums allow you to position or remove images quickly and simply by peeling back a plastic sheet. To prevent fading, don't leave prints in direct sunlight for long.

OVERLAY •
In this spiral-bound album, prints are held in place by a thin plastic overlay.

GLOSSARY

Words in *italic* are glossary entries.

A

- **AE** Automatic *exposure*.
- **AF** Automatic focusing.
- **Aperture** Circular hole formed by overlapping blades set within the lens that limits the amount of light reaching the film. The aperture diameter can be varied, and each different setting is given an *f-number*.

B

- **Bracketing** A series of pictures of a subject differing only in the *exposure* given. Useful when you are unsure of the correct exposure to set.
- **B setting** Shutter setting that keeps the shutter open for as long as the release is depressed.

C, D

- **Contrast** The difference in tone between the extremes of shadows and *highlights* in a scene or photograph. The greater this difference the higher the contrast, and, therefore, the trickier the *exposure*.
- **Dedicated flash** A unit that integrates with the camera's *exposure* circuitry. It gives out the correct amount of light for the *film speed*, the *aperture* setting, and the subject distance.

A camera carryall

- **Depth of field** The distance between the nearest and farthest parts of a scene that are in sharp focus at one focus setting. Depth of field increases as you *stop down*, move farther away from your subject, or change to a shorter *focal length* lens.
- **DX coding** System of labeling film cassettes so that *film speed* can be read and set automatically by the camera's *exposure*-measuring system.

E

- **Existing light** General term for lighting that is normally present – daylight or normal room lighting, for example – and is not set up or augmented for photography.
- **Exposure** The amount of light received by the film – a combination of time (shutter) and intensity (*aperture*).

F

- **F-number** Scale used to denote the diameter of the *aperture* relative to the *focal length*. The smaller the aperture the higher the f-number.
- **Fill-in** Light used to help illuminate the subject's shadow areas.
- **Film speed** Number denoting the relative sensitivity of film to light. Normally quoted as an *ISO* figure.
- **Filter** Transparent material – glass, gelatine, etc – that modifies the light passing through it.
- **Flare** Scattered light, reflected from the subject, background, or within the camera itself. It turns shadows grey and flattens *contrast*.
- **Focal length** Basically, denotes the light-bending power of a lens. Used at the same subject distance, a long focal length lens produces a larger image, and so fills up the picture with a smaller area of the scene, than does a short focal length lens.

G

- **Graininess** The visual appearance of the clumps of grain that make up the final processed image. These are

normally too small to be seen unless the image is greatly enlarged.

• **Guide number** A guide to *exposure* when using a flash unit. Divide the GN given for the flash by the subject distance to find the *f-number* needed (for 100 *ISO* film).

H, I

• **Highlights** The brightest parts of a scene or photograph.
• **Incandescent light** A light bulb that contains a tungsten filament. Most domestic lighting is of this type.
• **ISO** International Standards Organization. International *film-speed* standard used by most countries. Uses the same figures as the now outdated ASA system. A doubling of ISO figure denotes a doubling of film speed.

L, M

• **Long focus lens** A lens with a longer *focal length* than normal for the picture format – for example, longer than 50mm for a 35mm camera.
• **Macro lens** Lens designed to be used at close subject distances.
• **Motordrive** A motor that winds the film on after each frame is taken.

N, O

• **Neutral density filter** A grey filter that reduces the light. It allows a wider *aperture* or longer *exposure* time to be used without *overexposure*.
• **Open flash** Firing a flash unit one or more times while the shutter is open.
• **Overexposure** Giving the film too much *exposure*. It results in a dense negative and a pale print.

P

• **Parallax error** Inaccuracy at close focus distances between the image seen through the (separate) viewfinder of a compact camera and the scene recorded by the lens on the film.
• **Preview button** Available on some *SLRs*, this button stops the lens down manually to the *aperture* selected for the picture and so allows you to preview *depth of field*.

R

• **Red eye** Flashlighting effect where the pupils of the eyes appear red.
• **Reflector** Any convenient surface from which light can be reflected back on to the subject – white cardboard, walls, ceiling, etc.

S

• **Shutter priority** *Exposure*-measuring and setting mode in which the user selects the *shutter speed* and the camera sets the *aperture*.
• **Shutter speed** The time the camera shutter stays open and allows light from the subject to act on the film.
• **SLR** Single lens reflex camera.
• **Stopping down** Changing to a smaller *aperture* by setting a higher *f-number* – for example, f8 to f11.

T, U

• **Telephoto lens** Alternative term in general use for a long *focal length* lens.
• **Underexposure** Giving the film too little *exposure*. It results in a thin negative and a dark, flat print.

W, X

• **Wide-angle lens** A lens with a *focal length* substantially shorter than normal for the picture format – for example, 28mm for a 35mm camera.
• **X socket** Electrical contacts on the camera body, designed for connecting to a flash.

Z

• **Zoom lens** Lens with a special control that will allow you to alter the *focal length* within the camera's design limitations.

A tripod

INDEX

GETTING IN TOUCH

International Center of Photography
1130 Fifth Avenue
New York, NY 10036
212-860-1777

ACKNOWLEDGMENTS

Michael Langford and Dorling Kindersley would like to thank the
following individuals and organizations for their kind help and assistance
in the production of this book:

Sarah Lavelle, Jeremy Weeks, David Hemming, James and Ryan O'Donahue,
Kevin Williams, Amanda Lunn, Jo Weeks, and Laurence Henderson for modelling:
Jeremy Hopley and Rodney Forte for photographic assistance and modelling. Coral
Mula and Janos Marffy for illustrations. Sarah Larter for editorial assistance. Nikki
Vincent of Location Works.

Susie Keane of Nikon (UK) Limited, Mac of Hama Limited, and Richard
McKenzie of Kyocera Yashica (UK) Limited for the loan of cameras, lenses, and
general photographic equipment.

Stocks House, Holland Park, and Eastway Circuit for many of the outdoor
locations used in the book.

Additional photography by: Michael Langford – pp.26, 30-31, 32, 33b, 34, 39t, 42,
44-45bl & br, 57cl & cr, 58t, 59b, 61c, 62, 68, 69b, 72cr, 74, 76t & bc, 78, 79t, 81, 82bl
& br, 83t , cl, bl & br, 84c, 87cl & br, 88t & cr, 89t.
Madeleine Hilton – pp.14tl, cr & bc, 27b, 43t, 60tl, 60-61b, 76l, 77l, 82cr, 83cr, 87t.
R Francis (Action Plus) p.36.
(t=top, b=bottom, r=right, l=left, c=centre)

Stocks House, Near Tring, Hertfordshire. Tel: 044-285 341